Best wishes

John Ashbery

My Brush With Fortune

My Brush With Fortune

An Autobiography by

ASHLEY JACKSON

Secker & Warburg
London

First published in England 1982 by
Martin Secker & Warburg Limited
54 Poland Street, London W1V 3DF.

Copyright © 1982 by Ashley Jackson

British Library Cataloguing in Publication Data

Jackson, Ashley
　　My brush with fortune.
　　1. Jackson, Ashley　　2. Water-colourists –
　　England – Biography
　　I. Title
　　759.2　　ND1942.J/

ISBN 0-436-22035-0

Photoset in Great Britain by
Rowland Phototypesetting Limited, Bury St Edmunds, Suffolk
and printed by St Edmundsbury Press
Bury St Edmunds, Suffolk

I dedicate this book to my wife Anne, and to my two daughters, Heather, who I named after the Moors of Yorkshire, and Claudia, named after my maternal grandmother and godmother.

To life, for giving me, in my span of time, all the luck and all the health one needs to survive on God's Earth.

Acknowledgement

To Barry Cockcroft whose help and friendship I hold close to my heart. If not for him, this book, my autobiography would never have come about.

List of Illustrations

Black and White Plates

List of Colour Plates

Give me the Arts, for Art is Beauty.
Beauty is also in a woman.
But when I stand upon these moors,
I see beauty that never dies
As time comes and goes,
But woman's beauty fades away with time,
And equal to beauty is companionship, which woman has,
Funny, with both these gifts
One cannot touch them
Which is beauty itself.

Ashley N. Jackson 1967

Chapter One

There are moments in life which burn into the mind with all the permanency of a cattle-branding iron, fresh from the fire. It hurts, it confuses . . . but when the smoke clears there is clarity.

Positive identification.

Wandering distractedly through an Andalucian dust bowl in the summer of my fortieth year, I was to have several such moments.

But the first one will sting sweetly for ever. . .

I am Ashley Jackson and a lot of people know me. They buy my paintings and make me rich. Well . . . pretty comfortable. They point cameras at me and microphones and there I am – looking up at you from your breakfast table or issuing a merry quip from the corner of your living room. BBC, ITV, the dailies, the evenings . . . thousands of words, thousands of pictures.

I am that Yorkshire artist with the daft grin and the pancake flat vowels who paints the Dales and the moorlands. The one who used to be on Pebble Mill, the one who had that network documentary made about him recently.

Lucky old Ashley, they say. Did you see that big posh house with the heated swimming pool and the sauna? Thought artists were supposed to be poor? Thought they lived in garrets and ate baked beans?

Not this one. Not now. I am established, accepted, collected by the

discerning. I can afford clothes from Gucci. Ash the Cash one journalist dubbed me.

So successful, so happy, so stable. A well founded man living in permanent sunshine. That has been the image promoted by the media for ten years, and I helped them unreservedly.

And it is not a façade – not entirely. My work, my wife, my daughters, my success lit every corner of my being.

Except one.

And I did not even know there was such a darkness until the time came to stop and reflect. I imagine that happens to most men, when targets have been achieved and the fast flowing years bring on distinct feelings of mortality.

It happened to me as my fortieth year approached, which I have always considered to be the half way mark in life. The occasion was bathed in a rosy glow – at first. I had been accepted internationally as an artist (they were even wanting to market an Ashley Jackson paint box world wide), the bank manager beamed at me, I had ordered a new BMW and I had no need any more to attack life like a young bull.

So I sat high on the Yorkshire moors and thought about this life of mine, about the triumphs, the comfort . . . and then about just who I was and where I had sprung from.

And then slowly the temperature dropped. And there came a grey dawn which broke gradually and painfully through the next three years. The realisation that I had no real, positive idea of just who I was. What my true identity, even my nationality were.

It was like falling in slow motion off the edge of a cliff.

The crisis really began, I suppose, when I thought about my father and gazed for the ten thousandth time at the few pictures I have of him. I have always felt very close to my father. And yet I never knew him. Never spoke to him, never saw him – although my infant eyes must once have reflected his image.

I was a small child when the Japanese gave him a spade to dig his own grave and then shot him into it.

That has always hurt, and always will.

My father was born in Malaya and so was I. But then the lines of

identification become wildly mixed. He had a Spanish mother and a father who was reputed to be American but who may have been English. I have never been able to pin this down.

As for my mother, she was also born in Malaya. Her father was Scottish and her mother a Portuguese born in Thailand.

I have always considered myself to be English, although I never clapped eyes on this land until I was ten. More than that, even – a Yorkshireman, which is a special breed. My accent is as Yorkshire as Fred Trueman's.

And there I was, pushing myself as the man planted from birth in the peat moors and the limestone hills of Yorkshire. All my literature said so: 'Ashley Jackson, FRSA, Yorkshire Artist'.

The thought that I might really be an alien, a man with no real home, an imposter even, began to bear down on me with a mighty weight.

A sense of belonging is taken for granted by everyone else. Everyone else I know, anyway. Of all the great facts of life it is probably the one least appreciated. Everyone else knows just who they are, who their parents, grandparents and even great-grandparents were. They can look down at the earth around them and see their roots clearly, pushing deep down into the centuries.

I could find no similar comfort. The more I considered the untidy network of my origins, one thought drove through the mists with great force. I must look to my father and his line to see clearly just who the hell I was. My mother, bless her, could not help. The only positive avenue was through the one person, apart from my mother, who had been really close to my father.

His mother, my grandmother: Dolores Jackson. I had known her well and loved her dearly. She, sadly, had been long dead by the time this obsession took hold of me but I did have memories of her, and even some documentation to study.

But that led to even darker confusion.

By the time my fortieth year dawned, Anne had something very definite to say to me. Anne, my loyal wife, had watched and listened silently through these troubled days. Then she gave me wise counsel.

Stop work, stop painting, stop brooding. Go out and find your

origins. Take all the time and all the money you want. Get it out of your system. Travel. Go anywhere, everywhere, ask the questions and keep asking until the answers come.

So I did. First to London, then to Ireland and finally to Spain. For weeks I searched through old death and marriage certificates, analysed slender pieces of information gleaned from yellowing bits of paper, sepia photographs and fragile newspaper cuttings fifty years old.

New facts began to emerge. Incomplete, puzzling, disturbing – but facts, nevertheless.

Much happened on the road to Spain. But I arrived at the gates of the ancient city of Seville with excitement and hope. By then I was convinced of one thing: all the important answers were certainly hidden away in this corner of Spain. How well they were hidden I did not realise then.

But I was prepared to stay, and persist, until the end. For I knew that this *was* the end, the last stop on my strange odyssey.

There was simply nowhere else to go.

Two weeks later, I found myself in the baking hinterland of Andalucia, far away from the roar of Seville and with hope diminishing. Seville, for all its timeless beauty, had become for me a city of frustration, blank walls and shaking heads.

Towards the Portuguese border I had travelled, into a land where the loudest sound was made by the insects in the fields and bushes, singing their praises to a relentless sun. There the occasional huddles of seemingly deserted *haciendas* had remained unchanged and undisturbed, except for an occasional coat of blinding whitewash, since my father's mother trod the same path a century before me.

Ah, my grandmother! It was she who had sent me to Spain, sent me spinning for three long years. And she had done it all from the silence of her grave.

Grandma Jackson, Dolores Jackson. I had adored her and confided everything to her. She was the nearest I had ever been to my father. She talked to me of him, and of many things. She always called me Norman, never Ashley. Norman was my father's name, and my middle name.

18

Over and over she would tell me how much I resembled my father, in my looks and in my ways. Grandma and I were completely captivated by each other. I suppose she filled quite a large gap in my life. And I in hers. I was the replacement for the son she still missed very badly and she gave me the direction my father would have brought to my life had he lived.

It was Grandma Jackson who taught me manners, told me in my youth what was wrong and what was right. It was to her that I brought my bride to seek comfort and advice when family strife was breaking round my head.

It was she who gave me the strength to throw up my job, become a full-time painter and damn the consequences.

Her influence on me was profound. She opened many important doors for me.

Except one.

When I was an adolescent I spent my summers in Limerick, where Grandma Jackson had chosen to spend the closing years of her colourful life. She, too, had been an artist. An internationally celebrated artist. Her skill at dancing the Flamenco had taken her round the world in style, to Royal Command performances.

She was even summoned twice to dance for Queen Victoria.

These moments she would describe to me in vivid detail as I sat mesmerised at her feet in that tiny, terraced house in Wolfe Tone Street, Limerick. Her wealth had gone by then, her property confiscated when the Japanese over-ran Malaya.

How she could spin stories about travel to exotic places, meetings with famous people, the excitement of the theatre, the champagne and the romance. But about her childhood and her homeland she said little. I thought nothing of it at the time, but I did notice that when I occasionally showed an idle curiosity about her beginnings those large brown eyes of hers would go dull and reflective.

What she did say was brief, but dramatic. She had been born in Seville and her maiden name meant King in Spanish. Her father had died when she was very young and her mother remarried. Then, at the age of six, she had been sold to an American couple who ran a

travelling troupe of dancers. They took her to live in London and she had never returned to Seville.

Sold!

But I was too young to ponder the significance of that remarkable fact. It just seemed to blend in with the glorious uncertainty of her life when I heard it.

One day, towards the end of her life, Grandma announced that she had something to show me. From a locked drawer she produced a book – a small, red book. And she handed it to me with words that would eventually echo down through the years.

'Look at this carefully, Norman. One day you will think a lot about it.'

But to a young man with his mind on other things, such as girls and how I could get my daubs to become real paintings, it was just another picture book. Full of Press cuttings and photographs about a dancer called Chinita Zerega. I asked no questions.

Grandma Jackson was on her death bed when I last saw her. To get to her side quickly, I spent the money Anne and I had saved to get married to pay the air fare to Shannon.

There was no time for questions.

Only farewells.

Her death was a bitter blow . . . the breaking of the last link between me and my father.

In her will, Grandma Jackson made one bequest to me. The small, red book. She had little else to leave. At first, the book was merely a memento of someone to whom I had felt very close. For a long time I only glanced through it casually.

But when the grey dawn broke I read it over and over again. Seeking some ray of light, wishing a thousand times that I had asked her while she still lived to tell me more. Insisted that she should! Over and over again I recalled what she said when she first showed it to me. . . 'One day you will think a lot about it.'

I did, indeed. And through some sleepless nights.

And then I came across a strange sliver of apparently inconsistent information. Why I had not noticed it before baffles me. In a tiny, five line and fading Press cutting from the Singapore *Straits Times* of Lord

knows how long ago, pasted in a corner of the red book, there was a strange name. It was contained in a court brief about her divorce.

She had been named as Dolores Rodriguez Jackson.

Rodriguez? I had never heard that name before. And it certainly did not mean King in Spanish. I had checked that one out long before. That is Rey.

'One day, you will think a lot about it. . .'

I found a copy of her death certificate. And there was the name I had always known: Dolores Jackson. No help. In despair, I travelled to London. I knew she had married there, and I knew the approximate date. It took days of leafing through church registers before I found it. What I read I just could not believe. The bride's name was listed as Maria Therese Rodriguez, daughter of Manuel Rodriguez, gentleman farmer of Seville.

Marie Therese? She had always been Grandma Dolores to me. And the Rodriguez should have been Rey. But it had to be my grandma because there was the man I knew for certain she had married, the late and unlamented Theodore Stanley Jackson.

That was probably the lowest ebb of the crisis I endured. The realisation that I did not even know the true name of someone who had been so close to me. Neither Christian name nor maiden name!

Who the hell was I?

Back home I carefully questioned my mother and my maternal grand-mother but they were equally amazed by this revelation. I travelled to Limerick to ask Mamie White, Grandma's friend and constant companion in Limerick, but she could not help either. Grandma Jackson had confided in no one.

My brain boiled over with questions. What was the reason? What, in the name of Heaven, had she got to hide? I had to know. Nothing else at that time in my life was important.

Which explains why, three months later on a blistering afternoon in a remote rural area of Southern Spain I was sitting in the courtyard of a *bodega* watching Perdita Hordern trying, with growing embarrass-

ment, to tell me something. She was clutching the small, red book, and her hands flicked over the pages nervously.

For weeks Perdita had worked mightily to solve my problem. She had started as my paid interpreter, highly recommended by the British consul in Seville, but by then had become a friend, emotionally involved in the search for the truth about my grandmother. She had pounded around the pavements of Seville and its suburbs until her feet had swollen, checking every Civil Registry.

She started off with such enthusiasm and energy, declaring that if she could trace my grandmother's birth in one of the registries it would tell me everything I wanted to know – even the house where she and her parents had lived. And she did have an accurate date of birth to work on, plus a selection of names!

And yet, in the end, there was no trace at all. It was as though my grandmother had never been born.

Perdita was almost as discouraged as I was. I think most people would have thrown in the towel at this point, but she gathered new strength and took me step by step through every detail I had ever known about my Spanish grandmother. Then she began to look closely at the small, red book which we had skimmed through together during our first meetings. I agreed that she should borrow it for a few days.

For the first time since I arrived in Spain I had a few days to myself. To keep my mind occupied, to push aside the pressures I turned automatically to the one thing I do best. Painting. The old quarter of Seville fascinated me and I tried new variations of colour, light and shade to try and capture the atmosphere and the architectural embellishments of a Spain my grandmother must once have known.

The exercise refreshed my spirit and I was almost eager to start again when Perdita telephoned to arrange another meeting. I thought I noticed a strange edge to her voice – a definite decline in her customary warmth and bonhomie – but I dismissed it.

She specified a place a long way from Seville, in a village courtyard ablaze with pink blossom and throbbing with the full heat of an Andalucian summer. The inevitable bottle of Fino sherry was on the table between us and the sun's rays bounced blindingly off the glasses,

22

the starched white tablecloth and the freshly painted walls. I remember thinking that I would gladly have given a thousand pesetas to replace the Fino for a pint of Yorkshire brewed bitter, pumped straight from the depths of a cold Pennine cellar.

I knew by then that Perdita was a person who came directly and lucidly to the point. But that afternoon she stumbled around in verbal circles, her customary confidence apparently in shreds. I watched and listened for a while and tried to come to the rescue, assuming that she was trying to tell me that we must travel more dusty miles, endure more endless vigils as bored and underpaid clerks delved into files buried away in the outer limits of municipal archives.

'Don't worry . . . it's alright.'

I was anxious to reassure her.

'I'll do anything you want. Stay as long as is necessary. . .'

She cut me short.

'No, that isn't it. That's not it, at all. You see. . . I've got something important to tell you.'

We gazed defensively at each other across that gleaming table. Then she held up that familiar red book.

'I've spent a long time reading this. And I've shown it to other people, friends of mine. People who know much more about this kind of problem than I. Experts, really. And I have to agree with them, because I was beginning to think along the same lines before I even talked to them. You see, when you piece everything together . . . the fact that she was a Flamenco dancer, that she was sold as a child to a professional dancing group, that there is no trace of her birth although we know for certain she was born in Seville points inevitably to one conclusion.

'I don't know how you are going to take this, Ashley, but . . . the only people who didn't register births at that time, the only people who would have sold a child . . . were the gipsies.

'There is no doubt in my mind that your grandmother was a gipsy, a pure Spanish gipsy!'

Chapter Two

'But the first one will sting sweetly for ever. . .'

When the smoke cleared, two emotions collided within me. One was a great sadness which stung my eyes more than the brilliant sunshine. I wept for my grandmother, who had for all those years kept hidden from everyone, however close, this magnificently romantic fact. She must have been convinced that it constituted a disgrace. Poor woman. Such a burden must have cost her dearly in emotional terms.

The overwhelming feeling, however, was relief. It flooded through my body like a rip tide. I could see! See the detail, the reasons. Until then so much about me had been an out-of-focus smudge. Now it was becoming clear who I was, and why. And it was the knowledge of the Romany blood in my veins which resolved so many of the enigmas. The Romany, especially those with their roots in Spain, is artistic by tradition and temperament, living for music, dance and art in all its forms. Unpredictable, restless and proud.

I could see just how much of me sprang from this blood line. The dominant gene. It was from my gipsy ancestors that I had received the gift of artistic ability – and I have always known that it was an inborn gift, not something gradually acquired. It emerged too suddenly and too soon for that. I understood now why my emotions ran to further extremes than those around me. The euphoria which could so quickly change to deep melancholy, the regular need to lose myself for days on end walking the high moors alone. And the pride which drove me into ferocious battle against numbing odds when my paintings were scorned and derided publicly during the early years of my career.

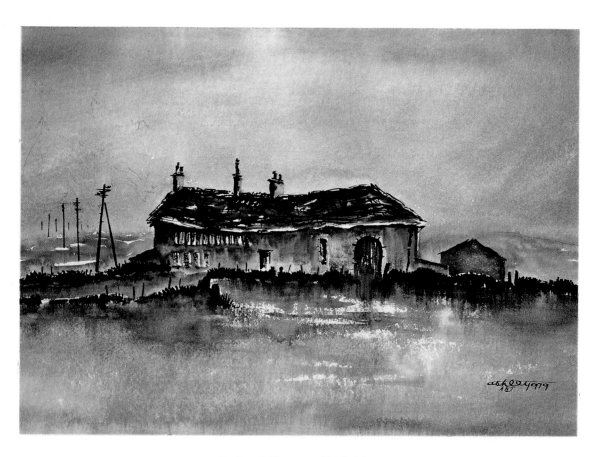

Isolated Cottage, Yorkshire

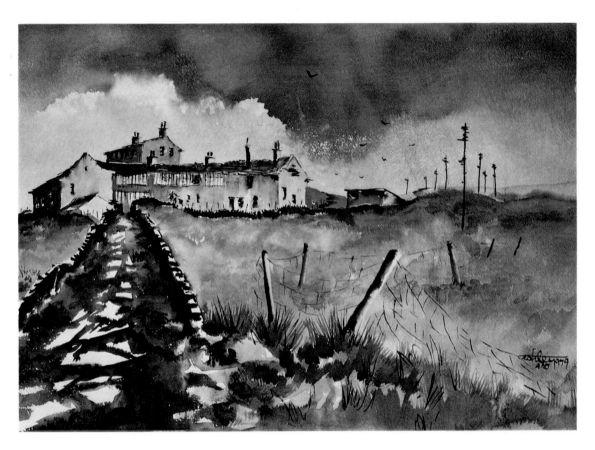

Workhouse, Haworth Moor, Yorkshire

The early years! Like my ancestry, those years were wildly mixed. Particularly my childhood. Before I was ten years old, I had known gentility and gracious living followed swiftly by despair and deprivation. But first came a decidedly splendid and cushioned life. My very first clear memory underlines that.

It was the day the Bear Charmer arrived, quite unexpectedly. At the time we were living in India – me, my mother, two grandmothers, three aunts and assorted cousins. A very large family unit, but our residence – that is the only word for it – in Bangalore was also large enough to accommodate a welter of servants. There was a cook, maids, *dhobi wallahs* to do the laundry, numerous assistants and an *amah* for each child. I cannot recall the name of mine so she could not have been very close to me. *Amahs* were more servants to children than nannies.

The occasion was my fourth birthday, duly celebrated with a well-mannered party just for the family, organised chiefly by Aunt Cissie, my mother's elder sister. No outsiders were present, for mixing with native children was not encouraged. We were allowed to run through the grounds of the imposing white bungalow, playing Chinese marbles and helping ourselves to fresh bananas from the trees. But there were no rough games because the aunts did not approve. Anyway, I was the only boy among the children and an exceedingly delicate boy at that, with platinum blond curls.

Suddenly, we children were galvanised by the arrival at the side gate of a very large, brown bear. Beside it was an elderly, bearded Sikh, wearing a floppy turban and flowing robes who had the bear firmly attached to a rope. My mother and the aunts laughed, as we all ran squealing with fear towards the house, and waved the Sikh to enter.

It had all been arranged as a special treat for my birthday.

We were ushered inside the courtyard to watch at a safe distance. Tubs of ice cream were distributed and the performance began. I vividly remember being amazed at the sight. I had caught glimpses of street corner snake charmers on outings to the native markets, even one who had a cobra and a mongoose, but nothing so spectacular as this.

25

The Sikh let the bear loose, which even unnerved the aunts a little, and produced a flute similar to those used by snake charmers and fashioned from a gourd. As he played, the bear danced ponderously around on its hind legs in the boiling heat, tongue sticking out and eyes glazed. Sometimes the music stopped and the Sikh would turn to my mother and Aunt Cissie, stretch out his hand and say 'Memsahib. . . ?' A few rupees would not only start the performance again but lead to even greater wonders. On command, the bear even turned somersaults which shook the sun-parched ground as its feet hammered down.

To a small boy it was a magical sight. The one birthday I would remember all my life.

I have earlier, less distinct memories of a house even larger and grander than the one in Bangalore. It stood, like something out of the Deep South of America, in Westlands Road, Penang, in Malaya, with Grecian style pillars, a canopy to the front door to shield visitors from the sun and an enormous open staircase. It belonged to my maternal grandfather, Captain Cecil Scott, who had been a regular army bandmaster. He had married a Portuguese girl and decided to stay out East when the time came for him to retire from the army. The place had become home for him and he also knew that he would never be able to match his life style out there if he returned to Britain. His pension and savings would have bought him a modest degree of comfort in the United Kingdom, but in Penang it meant luxury, servants, gin and tonics in the shade of the verandah and membership of the exclusive clubs.

My infant memory does not retain this, but I am told that my mother and father would drive up in a sports car to see my grandfather, be met at the canopy by Agwan, the head servant, and ushered deferentially inside. At the rear of the house, placed a discreet one hundred and fifty yards away from the main house, stood a row of small bungalows where the servants lived.

This was the environment in which my mother was raised. She never cooked a meal or washed a dish until she was well into her twenties.

Mother and father met when the Scotts travelled to spend two weeks indulging in a splendour which even outweighed that to be had in Penang. The Singapore of pre-war days, which has now passed into legend. Raffles Hotel . . . the cricket club . . . the afternoon tea dances. It was an exotic and enviable life for expatriates.

My Spanish grandmother settled in Singapore after her dancing career drew naturally to its close. She had become wealthy by launching another career as a business woman. She started and owned the local bus service and founded a small publishing house which had quite a success with books about Malayan and Spanish cuisine.

Naturally, grandmother also had a large house with servants and the usual comforts and led an extravagant social life. Everyone else like her did. The Jacksons and the Scotts had equivalent status so when the two families met, as they inevitably would in such a small community where the world revolved around the bar at Raffles, there was an instant rapport. Particularly between Norman Valentine Jackson and Dulcie Olga Scott. As the elders sipped their gin slings and gossiped avidly, they walked hand in hand through the warm moonlight and dallied amid the heady fragrance from the flowering trees.

And fell madly in love.

By the time the fortnight's holiday was over and the two families were saying their farewells, the young couple were officially engaged. It was to be six months before my mother and father met again – at their wedding in Penang. It was a posh affair, apparently, and quite riotous. They left to honeymoon in the Cameron Highlands and some of the guests turned up noisily drunk at their hotel on the first night.

My mother was seventeen. And I was conceived on the honeymoon. The couple went to Singapore to start married life in the house owned by my grandmother, Dolores. My father was very much the man of the house by then: ten years older than his bride, and his own father had vanished from the scene several years before. Theodore Stanley Jackson, it seems, was not an admirable man. I was told that his wife, my grandmother, made the money and he spent it. In the end, she divorced him. For a Roman Catholic lady in those days, it was a brave and difficult achievement.

Quite apart from his mother's business interests, father had his own

thriving career. He was the general manager of the Tiger Beer Company in Singapore. There is also a suggestion that he worked for British Intelligence as war loomed, but I have never been able to confirm this. Certainly, his best friend was a Japanese living in Singapore, and before he met my mother both men went on holiday together to Tokyo. For some reason, they were arrested and questioned. Unfortunately, the two men spoke Malay to each other during the interrogation, which angered the men conducting it.

That was the last time they ever saw each other. My father was allowed to return to Singapore but his Japanese friend was never heard of again. My Spanish grandmother was convinced that they had executed him as a traitor. And she also told me that she was sure my father was a marked man when the Japs entered the war.

Norman Valentine Jackson, my father, shouldered his responsibilities like a man. He had a sister, who had made a disastrous marriage, and two wayward young brothers to supervise. An important and exacting job to do, a position in Singapore society and a young, pregnant wife.

When the war came, he immediately enlisted in the Singapore Volunteer Reserve. As my birth grew nearer, so did the Japanese Imperial Army. My mother was despatched to Penang so that her own family could care for her during the final stages of her confinement. We were basically both Latin families and it was an accepted tradition for a girl to go back under her mother's wing for the birth of her first child.

I emerged into a troubled world on Friday, October 22nd, 1940, in the American Hospital, Penang.

Chapter Three

As everyone knows now, the defenders of Singapore pointed most of their big guns the wrong way. Seawards. They must have felt so confident and secure: impenetrable jungle at their rear, the British Navy – still alleged to rule the waves – and a lot of water protecting their front door.

Mother brought me back to Singapore where father had set up his own house for us and found that life had not changed much. Britain was under siege, short of food and pounded by the *Luftwaffe*, but the bar at Raffles was as crowded as ever with carefree, cosseted people. No shortages, no bombs, no worries.

My father, though, must have had his doubts. As 1942 dawned, he began to make plans to cope with the unimaginable. To begin with, he shipped his two younger brothers out to America and safety. Then he painstakingly arranged berths on various outward-bound vessels, taking care to keep us separate. Each family unit had to go on a different ship: my mother and myself on one, his mother and sister on another, and so on.

A pessimistic plan, maybe, but a life-saving move for us all. The Imperial Army swarmed through the 'impenetrable' jungle in overwhelming strength and practically strolled through the defenceless back door of Singapore. In the middle of all this tension, mother became pregnant again. But there was a disastrous conclusion. The baby, another boy, was born prematurely and died.

Of course, I was oblivious to the various dramas unfolding around

me. Less than eighteen months old and surrounded by doting aunts and grandmothers, I can recall little or nothing about it. Just fragmentary memories of large houses, confusing crowds and continual sunshine. But not one single mental picture of my father, not a word he spoke. The tremendous sense of loss I was to feel later in life might have been mitigated a little had there been a memory or two to lean on.

No doubt he was rather busy at the time with other matters: enlisting in the Singapore Volunteers, running his brewery, queuing at the shipping offices to arrange our escape. It could not have left much opportunity for him to spend time with me and imprint himself on my memory.

Singapore fell so swiftly that we nearly did not make it. The bullets were flying and the bombs falling as our ship steamed out towards the Indian Ocean. Father stayed behind to fight. So did all the men of both families: Grandfather Scott, back in the army again, Uncle Tommy, Uncle Ossie and Uncle Leslie. But to everyone's amazement – particularly the Japanese – there was little fighting to speak of. All regular and irregular forces were ordered to surrender to avoid bloodshed.

Had those who made that decision known just what they were condemning my father and thousands more to endure they might have thought it better to fight to the last man. It would have been quicker and cleaner.

As for my mother and me, we were lucky. So were the rest of our women and children. As the menfolk were marched into Changi Jail, the Japs launched a savage attack on the refugee fleet. Apparently, ships on each side of us were being sunk, much to the distress of my mother who had close friends travelling on more than one of the vessels she watched go down in a confusion of fire and shattered metal.

But we ran the gauntlet successfully, if somewhat uncomfortably. Regimental etiquette was rigidly enforced on board ship. The ladies of officers and their children were given the cabins, dependents of other ranks had to scramble for anything left. And since my father was just a volunteer, he had no rank at all. So we were obliged to live and sleep on the open deck, me huddled in the arms of my mother.

Poor mother! For someone still a teenager, used to servants and all

the creature comforts, it must have been a nightmare. I do not remember a thing about it myself.

We survived. Grandma Scott, on another boat out of Penang, travelled in comparative luxury. Her husband, after all, was a retired captain.

Some ships went to Australia, some to India. Remarkably, all the Jacksons and the Scotts ended up in India. And all in the same enormous field in Bombay. That may sound odd now, but the arrival of an ill-assorted and woefully disorganised mob of women and children fleeing from the Japs must have placed too much of a burden on the bureaucratic system. My mother insists we were left to wander distractedly around in the open, along with milling crowds of other frantic women and howling kids. Maybe the authorities were too busy attending to the needs of the officers' dependents.

Our luck held out. It must have been a chance in a hundred, but we virtually bumped into Grandma Scott. She scooped up her tearful daughter and grandson, and placed us firmly under her wing. Our status was instantly elevated when it was made clear that mother was the daughter of a regular army captain, however long since retired.

Eventually, the rest of the two families straggled into a clearance camp near Bombay. Including Grandma Dolores. The two elder women, one Spanish and the other Portuguese, took control and got everything organised. They had drive and they had influence. It was not long before all of us – twelve people, no less – were travelling sedately to Bangalore where it had been decided that we should settle for the time being. We took a large bungalow in the European quarter.

It quickly became a well balanced family structure. Two of my mother's three sisters, Addie and Ethel, each had a young child – Aunt Cissie was unmarried – and Grandma Dolores had brought Lola, the only child of her daughter, also called Ethel, who had died in Shanghai – of a broken heart, it was said, because her husband had treated her very badly. Poor Lola was very backward. Then there were two adolescents, Clive and Sonny Boy, my mother's two young brothers.

I was one of the three toddlers, all first cousins. Priscilla was the eldest and our natural leader. Then came Lesley, who was a year

younger than me. All our fathers by then were prisoners of the Japanese.

There was a great flurry of activity as the women supervised the domestic arrangements. Furniture was moved around, servants hired and tradesmen interviewed. Life was re-established along a familiar pattern. All the old privileges were there to be enjoyed, just as in Penang and Singapore. The one difference, perhaps, was the erosion of the traditional class divisions between the Europeans because everyone, however senior their status in the Army, or the British civil administration, felt threatened. There were constant rumours that the Japs were driving remorselessly towards India, and people drew closer together as a result.

The sudden arrival of four attractive and vivacious young ladies into this environment caused quite a stir, even though three of them were only temporarily unattached. It was particularly evident in the various regimental messes in the area towards which the family naturally gravitated because of Grandpa Scott's military connections. A constant stream of young officers arrived at our front door, together with showers of engraved invitations to regimental balls, cocktail parties and the like. The US Army had a unit stationed nearby, too, so American accents began to augment the chorus of more refined voices echoing in our hallway.

Eager subalterns fussed over me in an attempt to please my mother, bringing lavish gifts and treasured military mementoes. I only had to hint that I would like this toy car or that regimental badge to have it miraculously appear and my three-wheeler bike was impressively decorated with Military Police insignia.

There was nothing improper about this situation. Everyone knew that all but one of the young ladies had husbands with honourable military records, now prisoners of the Japanese, and this was duly respected. But merely to escort one of them to a dance or to the races must have been a feather in the regimental cap of any young officer in a country where available and socially acceptable European women were very thin on the ground.

Anyway, the two grandmothers were always hovering around

protectively, acting as chaperones where etiquette demanded. And they also had the experience to spot anyone with the wrong motives well before any embarrassing situation could develop. I can imagine many an overheated young man beat a hasty retreat down our dusty drive.

Aunt Cissie, however, was very definitely eligible for marriage and most of the flowers and boxes of candy arrived for her. And she very quickly lost her heart. Not to a European, but to a handsome Indian from the powerful, almost regal Khan family. Safta Ali Khan, a relative of the Aga, was a Colonel in a very superior Indian regiment at the time, and finished as a Brigadier. He whisked Aunt Cissie away to an exotic life and she gave birth to Evelyn, who came to that momentous fourth birthday party of mine.

He and my aunt are still together and happy. They bridged the racial and religious differences without effort.

All in all, our bungalow throbbed with activity and visitors, laughter and music. Grandma Scott was an accomplished pianist, as befitted the wife of a regimental bandmaster, and all the sisters had good voices. Their imitation of the Andrews Sisters became so celebrated that they were invited to sing on the all-India radio network. Naturally, anyone throwing a party for miles around tried to persuade such a star attraction to attend.

Had they known what was happening to their menfolk things would, no doubt, have been very different. At the time they took comfort, falsely based as it turned out, from the fact that my father and uncles had been removed from the dangers of the front line. There was no hint then of the atrocities being committed in the prisoner-of-war camps, no information about forced labour on jungle railways. The few letters that did find their way to India were heavily censored.

Indeed, the one person they really worried about was me, particularly during the first eighteen months of our stay in India. The heat devastated me. Singapore and Penang had a light and pleasant temperature by comparison to the leaden and oppressive atmosphere of Bangalore. I began to suffer from fits and black-outs, and after one severe bout I lost my sight for a few days. Doctors and consultants

were called in and I spent weeks in a darkened room with *punkah wallahs* working overtime on the fans to keep the air moving. I was about three at the time and medical opinions agreed that I would soon grow out of it. But the malady persisted.

One day I launched into a mighty convulsion. My tongue went back and when mother came hurrying to my side I was lying apparently lifeless on the floor. Still too young to cope with an emergency of such dimensions, she ran screaming from the room. But Grandmother Dolores kept her head. She shouted for a spoon, hauled me off the floor by my feet and hung me upside down. Handing me to mother, she spooned my tongue out with one hand and thumped me violently on the back with the other.

Thus, I was pounded back to life again. But for my Spanish grandmother I suppose that would have been the end of Ashley Norman Jackson. When I heard this story many years later whilst sitting at her feet in Limerick it helped forge the emotional bond which later became so important to me.

After that drama I began to improve and grow stronger. On reflection, it was a good and illuminating childhood. Tiring sometimes of the exclusively feminine company of my cousins I would wander into forbidden territory – the houses of the servants and other local natives. The sights, the smells and the way of life fascinated me. The floors of their huts were made from sun-baked cow dung and I often sat cross-legged with the Indian kids, joining in their games and learning new words and phrases. They ate some strange foods. The one I remember best was the Dourian fruit, which was the size of a rugby ball and covered with spikes. When you split it open it had four large seeds surrounded by a creamy fibre which had a glorious taste. But it also had a putrid smell which most Europeans could not tolerate. I loved them, and the enormous water melons and all the other fruits – some, like the bananas, you could pick straight from the tree.

I was taught how to play marbles in the Chinese fashion and taken on adventures in the jungle – well, more scrubland, really, but it certainly felt like a real jungle to a European boy playing Mowgli and there was a certain amount of danger to spice the excitement. There may not have been Bengal tigers lurking around, but there was the

occasional snake and plenty of 'bandy goats' – huge rats which were reputed to attack humans.

Mother and the aunts were distinctly displeased when they caught me wandering off like this because it broke two rules: running around where there might be snakes, and associating with the children of *dhobi wallahs*. But I noticed Grandma Dolores did not join in the scolding too often. I was always her favourite, after her stricken grandchild, Lola, who was withdrawing more and more into her own world. And I was gradually beginning to look more like my father, whom she idolised.

When the heat of high summer became unbearable for Europeans, the family began to join the social stream moving out towards the cool of the hills. Eventually, we acquired our own summer house in Naini Tal and travelled there each year by train. Naturally, we always had a private carriage – nothing else would have been socially accept-able – and took the key servants along. During the final stages of this long haul, the train would stop to take on more water before straining every sinew to climb the steep gradients. There were other, hugely fascinating journeys by steam train across the Indian sub-continent. At certain times of the year it was fashionable to travel to Delhi, Bombay, Lucknow and even Ceylon. I enjoyed visiting them all, par-ticularly when we hired a *tonga wallah* and rode in an open, horse-drawn carriage very similar to the landaus in Blackpool.

For the Europeans, such luxuries were cheap. We had plenty of cash coming in – service pensions in abundance, and the company which employed my father still sent money regularly to my mother. This extravagant life lasted for almost four years. But it turned out to be falsely based and very quickly began to change.

First of all, Sonny Boy came of military age and insisted on going to fight, not a popular move with the womenfolk. He went away to become a *Chindit* with General Wingate's Fourteenth Army – later celebrated as 'The Forgotten Army'. Then news of the way the Japs were treating their prisoners began to filter through and letters began to hint about their desperate situation through the deletions of the censors. Malaria, dysentery, shortage of food. . .

35

From then on disaster followed upon disaster. Sonny Boy was captured. We heard later how he was put to work on the terrible Burma Railway, which claimed thousands of lives. Already among the slave labour there were Grandpa Scott, Uncle Tommy Scott and Uncle Leslie Laker. But not my father. His position was even more serious. It seems that his spirit – maybe the gipsy blood in his veins – rebelled against slavery and he made more than one strenuous effort to escape. But he had been re-captured and sent to a special camp in Borneo, which appears to have been an exclusive club – a kind of Oriental Colditz. Only much, much worse. It seems there were fewer than thirty prisoners occupying it.

As the Japs were finally driven back, the survivors came straggling out of the jungle, Sonny Boy included. Grandpa Scott and Uncle Tommy also returned, more dead than alive. And then came the letters, signed by Duncan Sandys and delivered personally by the officers from the local regiment. One for Aunt Ethel, Leslie Laker's wife. And one for my mother.

'Missing, presumed dead. . .'

I heard the wild sobbing from my mother's room and wondered what could be the matter. But within the day I was whisked away by Aunt Cissie and Uncle Safta. That house was no place for a small boy.

Later, we pieced together a few more details about the way my father died. There will never be a way of finding out the full story, but apparently Australian troops were advancing on that camp in Borneo. So the Japs gave my father and every other prisoner a shovel. They were ordered to dig their own graves.

How can such things be possible! Even today, the thought of my poor father putting his shovel aside and turning to face his executioner turns my blood to ice. I confess that I did hope for years that when the Australians finally arrived and found out what had been done they opted for summary justice.

Thus, as the war drew to a close and other families celebrated the return of their loved ones and looked forward to a full and normal life again, our entire world lay in ruins. Still not much more than a child, my mother was stricken by grief to such an extent that Aunt Cissie and her wealthy husband offered to adopt me and bring me up with cousin

Evelyn in India. They reasoned that mother would eventually want to rebuild her life, perhaps even remarry, and that I might be a burden – or, at least, an impediment.

Thankfully, she refused to consider the idea. Otherwise I might have ended up as an officer in Uncle Safta's regiment because the Khans were a military family, and Muslim, of course. The Pakistani army contingent which paraded through the streets of London at the Queen's Coronation was led by one of Uncle Safta's brothers.

Grandmother Dolores also found it difficult to come to terms with the death of my father. Her world had revolved around him, and I was to learn later that she clung pathetically for years to a belief that there might have been a mistake. That perhaps he had managed to escape and would turn up some day. Apparently, this hope was revived every time there was a story in the newspapers about soldiers emerging from the jungle years after the end of the war. But they were usually Japanese.

And then she left my life. Raoul, one of her younger sons sent to safety in America by father, turned up in Limerick and married a local girl. He invited grandmother and Lola to come and live with him. So she sailed away to Ireland, leaving one very unhappy and confused grandson waving tearfully from the quayside. It was to be many years before I saw her again.

I was five. My future was bleak and I think I knew it.

Chapter Four

It was not long before I, too, said farewell to India, land of my childhood. Grandfather Scott recovered sufficient strength to take over the leadership of the miserable remnants of the family group and decided that we should be on the move as soon as possible.

He had two powerful weapons with which to carve his way through the bureaucratic barriers – he was Scottish by birth and he belonged to the officer class. Alone, he travelled back to his homeland and quickly arranged passages so that the rest of us could follow him, with the exception of Sonny Boy, who had to stay and wait for demobilisation, and Aunt Cissie, of course, who made her home there from then on.

Travel documents arrived for eight of us – mother and me, Aunt Addie and Priscilla, Aunt Ethel and Lesley, Grandma Scott and Clive. We silently packed large trunks with clothes that would shortly become useless. Kashmir silks, thin cotton shirts and blouses, open sandals, fancy bonnets worn to race meetings and regimental garden parties and other hot weather gear. We trailed sadly away from that sparkling white bungalow in Bangalore, away from a life of comfort and privilege.

The boat was a luxury liner which had been converted into a troop ship so this sea journey was in complete contrast to the one endured by my mother and me when we fled Singapore in 1942. I enjoyed it. We all had cabins and I appreciated the air of excitement and anticipation all around after the long weeks of mourning. They threw logs over the stern as the ship steamed away from harbour, to bring good luck I was told.

It was a very slow boat. We were at sea for eight weeks before the grey shores of Britain, a land I had never seen before, came into view. And as we steamed towards the Clyde and Glasgow, cousin Lesley came out in a rash. It was confirmed as chicken pox, the entire boat was placed firmly in quarantine and we had to ride at anchor for four more days. We children thought it most amusing, but there was mass frustration and exasperation in all other quarters. Not to mention some embarrassment for Aunt Ethel.

In one sense, our beleaguered family was to stay in quarantine for another two years. I do not suppose anyone had given much thought as to what would happen to us when we arrived in the United Kingdom. Most of the adults had been numbed by tragedy and presumably just went along unquestioningly with whatever tide was flowing.

Like all Europeans in Asia, we had become accustomed to having people at our beck and call, to being treated with deference. There was always someone around to take care of things, and usually an officer, at that. But now our status had changed dramatically. We were now war refugees! We actually had to fend for ourselves, or do without.

I can only imagine what my mother, the aunts and Grandma Scott thought as they were trundled across Glasgow to a place called Bridge of Weir, near Paisley. For there they were ushered into our new home – an abandoned army camp! We were quartered, along with other refugees, in a draughty Nissen hut with a corrugated roof. There was not much privacy, for the partitions in the hut did not reach to the ceiling. And even less comfort. Heat was provided by a solitary coke stove in the middle of the hut; we had to fetch water in buckets and queue up for food in a bleak dining hall. The shock to all our systems was profound. Never before had any of us been obliged to do such menial tasks.

When winter came, the cold was unbelievable. Snow actually fell on and around us. Until then, I had only seen this phenomenon in the far distance when we travelled to our summer home in Naini Tal. Nor had I ever worn an overcoat before, but we were all exceedingly grateful

when the Red Cross came round and distributed long, khaki trench coats and big boots. We slogged round that camp like deserters from the Russian front, no longer the proud Colonial family.

I recall being struck by another contrast – the smells of Scotland. The damp odour of heather and peat moor was pleasant but the stench of diesel fumes from the buses and lorries in Glasgow made me nauseous. I had grown up with the garlic-laced curry smells of Bangalore and the scent of blood-red betel nut juice.

Grandfather Cecil Scott was the only one of us with something positive to do. He travelled around to Edinburgh and London, busily negotiating for the purchase of musical instruments. He planned to return to Penang and re-organise the band he ran before the war. He seemed to like Britain but the women were understandably unhappy despite the occasional treat of a trip to London. Mother and her sisters eventually recovered sufficiently from the shock to go dancing on a Saturday night at the Mecca Ballroom in Glasgow, but how different it must have been to the social whirl of India.

Clive and I were sent to school in Scotland but we rarely arrived there. Our parents were unaware of our truancy because there was little or no communication between the school and the camp. I do not suppose we were very welcome, although I must say the ordinary Scottish folk were very warm and friendly. So we would set off with pencils and exercise books and usually make straight for the river, which we found an absorbing place.

It was here that I first felt the urge to create pictures. Whilst Clive and sundry other children fished and made rafts, I used my school-books as sketchpads and tried to draw the river, the trees and the hills in the distance. When my birthday came I demanded a paintbox and began to colour in my sketches. It was an entirely spontaneous action. I had no example to follow nor any encouragement to take an interest in art.

Clive later took me on bus trips to Loch Lomond, only a few miles away from the camp. I was really moved by the beauty of the place, and tried desperately to capture the storm clouds and purple slopes.

But as far as my formal education was concerned I was off to a dismal start. When the school teachers finally rounded us up and sat me

down to an Abacus and the Happy Venture books, they despaired. I could not spell, read, add, subtract, anything! It was no happy venture for me – I was bottom of the class.

Away from the misery of school I was happy enough. The family was still a united and harmonious group and the cousins stuck protectively together round the camp, which had plenty of diversions for young minds. I even had my first sexual experience there. She was thirteen, more than twice my age, and we were surprised one day by our mothers while playing 'doctors' in a tent constructed from a clothes horse and a blanket. I only remember the row that ensued, not what happened under the blanket.

All this time, urged on by a continual chorus from his womenfolk, Grandpa Scott was strenuously trying to get us out of that camp and back to the place which was actually home to us: Malaya. Clearly, the family was never going to adapt to the spartan life of post-war Britain. Certainly not the adults, not after the life they had led there. Anyway, we were aliens in all but name and most of our property and belongings were in the Far East.

So were our hearts.

It took nearly two years, but one day in 1947 there was an explosion of joy in our corner of the Nissen hut. The sailing date had been set, and from then on life bubbled with the packing of trunks and the excited conversation and elaborate planning of our mothers.

The voyage back to the South China Sea plunged us happily back into something close to the life we had been missing. It was a holiday liner and many of the other passengers were expatriates like us . . . Europeans intent on returning to their old life, to reclaim their possessions and start from where they had so painfully left off. Very definitely officer class. Mother and the aunts were in high spirits.

We landed in Penang in a state of euphoria, revelling in the warmth of the sunshine and glad to eat the exotic foods and fruits again instead of the porridge, boiled beef and stewed cabbage of the refugee camp. Grandpa Scott found his mansion reasonably intact: badly in need of maintenance, over-run with lizards but quite habitable. Some of the old servants were still around but others had gone for good. The

41

Japanese had been particularly hard on the Chinese community in Malaya and many had been killed.

But when we reached Singapore, the happiness evaporated immediately. What we had left behind did not exist any more. Both the family houses – father's and grandmother's – had been razed to the ground. We were told horrific stories about the fate of the servants. Some of the Chinese had had their bodies filled with water and then they had been jumped on until they burst.

Not a single possession was left. And all the companies in which we had shares had closed down for good. Mother had been relying heavily on them to augment the income from her pension.

There was only one thing to do. Mother and Aunt Ethel retreated sadly back to Penang to seek shelter with their father; sisters united in despair and widowhood. Grandfather did his best to revive his daughters. His own energy and drive was fully restored and he threw himself into all kinds of projects, encouraging everyone to take an interest.

He was very much a character – almost an eccentric in fact. During very hot weather he would declare the house to be far too oppressive for occupation and order his servants to pitch a huge tent on the main lawn. Really, it was more like a marquee, and he moved in with his bed, furniture, carpets, library and his instruments. From Scotland he had brought his new toy – a set of bagpipes. As he resided in solitary state in his tent, the wail of the Highlands would drift across the garden and through the sultry, tropical night to my bedroom. During this time he favoured the native *sarong*, which made a change from the kilt he often wore. But his main passion was the municipal band, re-formed under his direction with the instruments brought over from Britain. He was quite a man, my grandfather. He must have held the family together in those days. Mother and Aunt Ethel responded to his urgings to get out and do something: such as find a job. Not just for the sake of their morale, either. They both needed the money.

Together, they went back to Singapore and became switchboard girls. It was a real come down, as they say in Yorkshire, but far better than sitting around the house all day pining for the past.

By then I was rising eight, and it was decided that Lesley and myself

should remain in Penang. Uncle Ossie and Aunt Addie insisted that we both come to live with them, which pleased me because it meant I would be with their daughter and my old comrade-in-arms from India, Priscilla. Uncle Ossie was also quite well off in his own right.

It proved to be the start of a glorious boyhood. The sunlit days sped by with a thousand exotic pursuits. We had relatives across the strait in Butterworth who owned a rubber plantation and a stable full of horses. Weekends were spent riding through the trees and ripping the fresh rubber as it dripped down the trees into wooden bowls. Raw rubber had endless fascination for a boy and the local native children taught me how to use the stickier stuff to catch magpies.

A captive bird would be placed as a decoy in a bamboo cage with a long stick protruding from it. This was carefully smeared with the freshest and most glutinous rubber milk so that when, as they inevitably did, wild magpies came to inspect the decoy their feet were welded to the stick. Grandma Scott was horrified when she found out about this dubious sport. Not so much because of the cruelty. The magpie was supposed to be a very unlucky bird and she was most superstitious.

Later, under the expert tutelage of the local lads, Clive and myself graduated to hunting snakes – including the occasional cobra – by using a variation of the same method. The bird in this case was usually a Java sparrow because they were cheap and plentiful in a place where cage-birds were universally popular. It was tied by a leg to its cage which was then left in a part of the bush known to be frequented by snakes. The door to the cage was lifted by a piece of string suspended over a handy tree.

Invariably, the cries of the distressed bird would attract a hungry snake and as soon as the last coil slithered into the cage the door would snap shut. Clive, now quite grown up, became expert at extricating them without getting bitten. He sold them to local pet shops – apparently there was a constant demand from snake charmers.

Now, of course, I realise what a stupidly dangerous pastime this was but the bush was a pretty hazardous playground by any standards. Apart from the snakes, the place abounded in scorpions, centipedes a foot long, plants which could bite, and the same

unpleasant bandy goat rats I had known in India. But the flying snakes scared me more than anything, including cobras. They had fold-away wings and could glide down from the trees; and they had enough poison to kill you.

One day, as part of a game, I ended up tied to a tree – all alone. Suddenly a flying snake came swooping along and landed at my feet. I do not think I have ever been so terrified in my life and my screams brought startled playmates running from all directions. They quickly chased the snake away with sticks but from then on my taste for snake hunting diminished noticeably.

But I had become a different child to the weakling of Bangalore. I had grown a sturdy frame and my platinum blond hair had changed colour dramatically. My head was well on the way to being as black as my father's.

Spanish black.

School was still a problem and various teachers tried in vain to improve my poor standard. Lessons began at seven in the morning, but by one o'clock in the afternoon we were free and I could run wild with my cousins and our pals. Cricket and football were practically unknown among the children we mixed with in Penang, except for Siamese football where the ball is kept aloft by feet, head, knees and elbows. We were content with the bush and the beach.

Nightfall was always eagerly awaited – there are no dusks in South-East Asia – because it meant we could chase fireflies and dig for stars in the sand. For some reason, the sand in Penang reflected the stars with amazing clarity.

Grandpa Scott kept a benevolent eye on me during these carefree, Huckleberry Finn days, occasionally summoning me to drive with him in his open topped MG down to Georgetown to help him shop for the latest sheet music or inspect new uniforms for the band. I would sit proudly in the Botanical Gardens watching him wield the baton from his rostrum.

He was always involved in something novel, and usually extravagant. Great fun – every lad should have a grandfather like him. And I

suppose I must have responded gratefully to his interest, since, he was the nearest thing I had ever known to a father. Up to then.

One serious flaw began to develop in my life as I approached my ninth year. It was mostly my own fault. At first I was very happy with Uncle Ossie and his family. Every Saturday night he would pile the kids into the back of the car and take us to the open air cinema. The Abbott and Costello movies were the great favourites and we were always bought a giant, flavoured ice-ball to chew. But there was another, hateful ritual on Saturday mornings. Priscilla, Lesley and I were made to stand in line for a spoonful of castor oil – to keep us 'regular'. It was taken with mouth open and nose pinched, and it made me retch.

A year after my mother left for Singapore I became difficult. A rebel. I had fights with my cousins. I refused the castor oil and my school career touched new depths. What I really needed, I suppose, was a real father and consistent discipline. Better still, a mother and a father.

News of my behavioural problems had to be sent to Singapore, and mother made flying visits to try and sort things out. She heard that I had been complaining that Priscilla had a bike and I did not. So she turned up on my birthday with a superb machine as a present . . . except that it was a girl's bike!

It came to the stage where nothing pleased me. I must have been a spoiled brat of the worse sort. The climax came just before one Christmas when I committed the ultimate sin. Grandpa Scott was quite artistic and each year created a Nativity scene, using antique and beautifully made lead soldiers for the figures of Joseph and Mary, the shepherds and the Kings. Each one was painstakingly dressed in robes, hairpieces, beards, everything. All done by hand. He would show them to me with such pride.

I stole them. Sneaked into the house and ran off with them. Took them back to Uncle Ossie's house, ripped off all the clothes and beards and played toy soldiers. When Grandfather discovered their loss he went mad. One by one his servants were marched before him and accused of the theft. The interrogation lasted a full day and even Agwan, the trusted head servant and a woman of position in her community, was denounced.

45

Priscilla knew the truth, and in the end it was decided that I must go to grandfather and confess. That experience was the worst of my life up to then, and the memory still makes me cringe. He did not even raise his voice when I told him – if only he had. Instead, he cried. I had humiliated him in front of his servants. Me, his only grandson. He was also my Godfather and he doted on me. I was made to go to each servant and humbly beg their forgiveness, especially Agwan's. It was a very black day.

Not long after that episode, I was packed off to my mother in Singapore. I suppose they had had their fill of my behaviour and, in retrospect, I cannot say that I blame grandad or my uncle and aunt.

Mother was not at all pleased. She loved and missed me but my reappearance – the circumstances of which were hardly worthy in the first place – could not have come at a worse time for her. Completely unknown to me, her life was on the brink of a dramatic change. And mine, too.

Chapter Five

When the war ended, several enterprising British servicemen who had served out East decided to stay there. They realised the unlimited opportunities for a vastly superior life and career to that which they could reasonably expect back home. Any European, and particularly the British, could reasonably expect to ascend quickly to a top job.

It must have been galling for the intelligent and ambitious locals – the Malays, Indians, Chinese and Eurasians. Most of them had to make do with the career crumbs from the table of the British lion. Much of the business life and associated capital was firmly controlled by a European élite and they rarely allowed outsiders to join their exclusive club. Rewards at management level were high – and living costs low. Native labour could be had for pence, and during the war even army privates could afford a servant.

Hedley Haigh, out East with the Royal Artillery, was one of those who chose to be demobilised in Singapore, having reached the rank of sergeant. He hailed from Yorkshire and demonstrated all the qualities for which Yorkshiremen are renowned. A very positive character, indeed: he was blunt, authoritative and believed that children should be firmly disciplined.

Hedley became the manager of a cold storage company in Singapore and met my mother when she called at his offices one day. She was in her middle twenties, dressed in the height of fashion and very attractive. He was a little older, possessed of much self-confidence and said to resemble Alan Ladd, a notable screen hero of the day.

They fell in love.

But the course of their romance did not run smooth. When news of it eventually reached the ears of top management in the cold storage company, lips were pursed and heads shaken. A rigid code of conduct in these matters was enforced by most companies controlled by Europeans, designed to ensure that the élite kept their blood line 'pure'.

It was permissible, indeed commonplace for single young executives to take a Malaysian or Eurasian mistress. Providing it was done discreetly, of course. But contracts usually specified that any intention to marry had to be approved by the board of directors, and those who attempted to wed local girls were severely discouraged: sacked, in some cases and demoted in others. And mother was classified as a local girl.

In vain, Hedley protested that she was European, the daughter of a Scottish army captain. But they pointed out that she had been born in the Far East, her mother was Portuguese and that she certainly looked local.

So their courtship had to continue in secret. It was all perfectly proper, of course. Mother lived with Aunt Ethel and Hedley had his own house.

So when I arrived in disgrace from Penang mother was understandably preoccupied. As for me, I was completely unaware of the existence of Hedley Haigh and was to be kept in ignorance for some time. If knowledge of the new man in my mother's life had been passed to the adults in Penang no one had said anything to me. Anyway, I had my own major problem to cope with as soon as I stepped from the train: school.

Mother took me straight to a boys' boarding school. It was expensive, run by Franciscan monks and housed in a beautiful old building, surrounded by magnolia trees and entered through a large and impressive wrought iron gate. As mother led me through, she tried to allay my fears by telling me that this was the very school my father had attended, and all his brothers. She pointed out, quite correctly, that my education up to then had been sadly lacking. This was the school to bring me up to scratch.

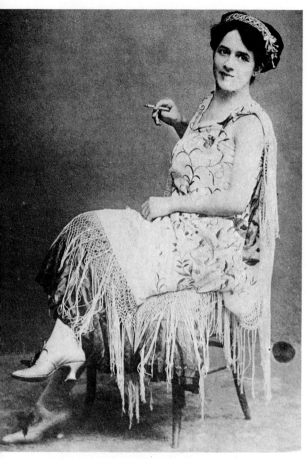

The author's paternal grandmother,
Flamenco dancer Chinita Zerega

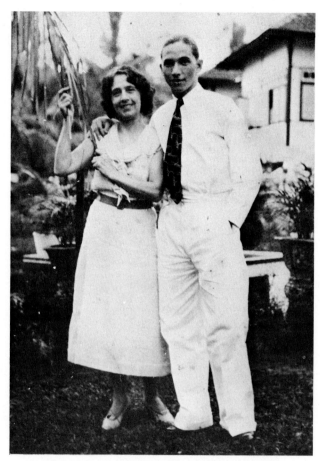

The author's father and grandmother in
Malaya before the war

Norman Jackson and Dulcie Scott at their wedding

IMPERIAL JAPANESE ARMY

I am interned in. KUCHING (BORNEO)

My health is excellent, usual, poor RECEIVED TWO LETTERS, JUST GOT OVER MALARIA. THIS IS MY 3RD CARD. MISS YOU EVER SO DEARLY AND ANXIOUSLY WAITING FOR OUR REUNION.

I am working for pay. DO NOT WORRY SEND VITAMINS (A)(B)(D) CIGARETTES ETC. LOOK AFTER YOURSELF, MUM & LOLA

I am not working. KEEP SMILING "EVERY CLOUD MUST HAVE A SILVER LINING"

Please see that you, ASHLEY, MUM, REST, KEEP FIT AND SMILING is taken care.

My love to you. ASHLEY, MUM & REST

Norman

A letter sent from the Japanese concentration camp in Borneo
where Norman Jackson was interned, and later died

Norman Jackson

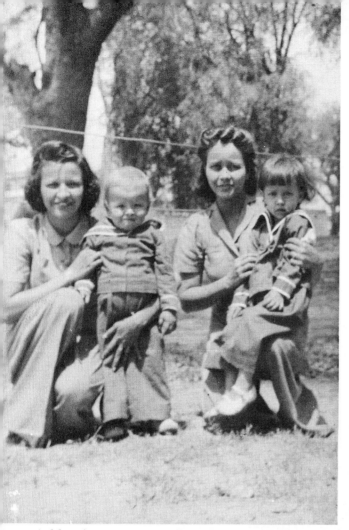

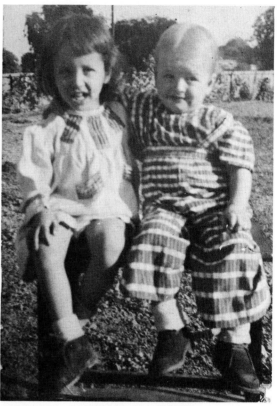

Ashley, his cousin Priscilla and their mothers,
Dulcie and Eddie in India

Priscilla and Ashley

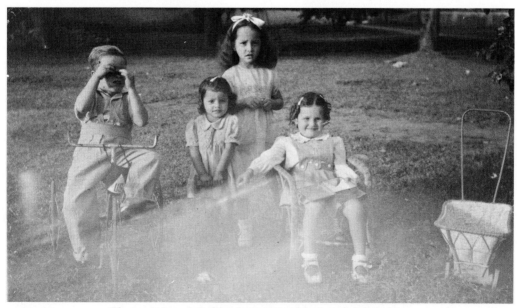

The cousins at Ashley's memorable fourth birthday
party – also attended by a dancing bear

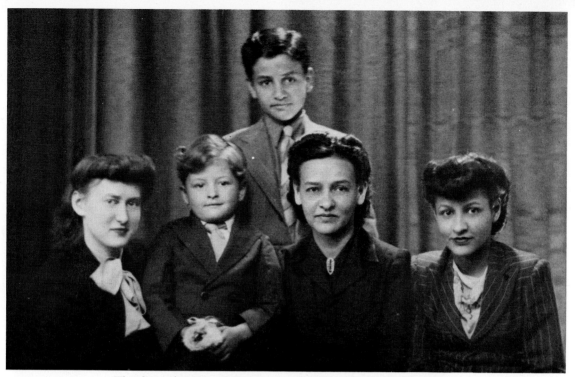

The Scott family at King George's Silver Jubilee celebrations

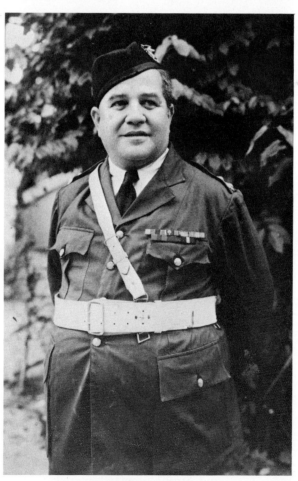

Grandfather Scott

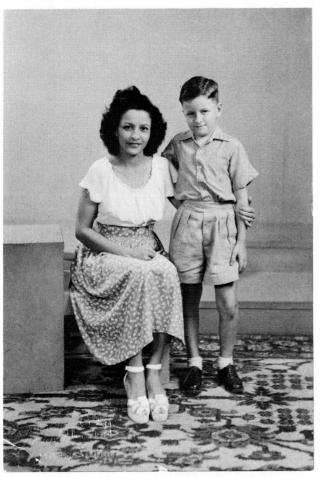

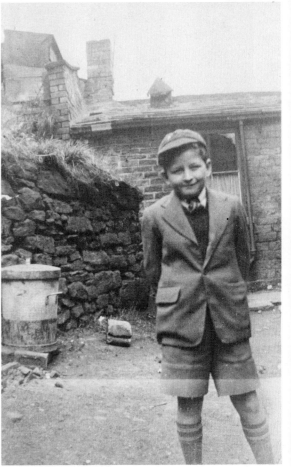

Ashley and his mother before their final
departure from Malaya

Ashley starting a new life in Huddersfield,
Yorkshire

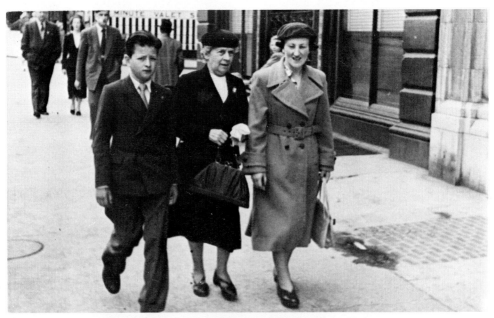

The first of many holidays with Grandma Dolores
and Aunt Mamie in Limerick

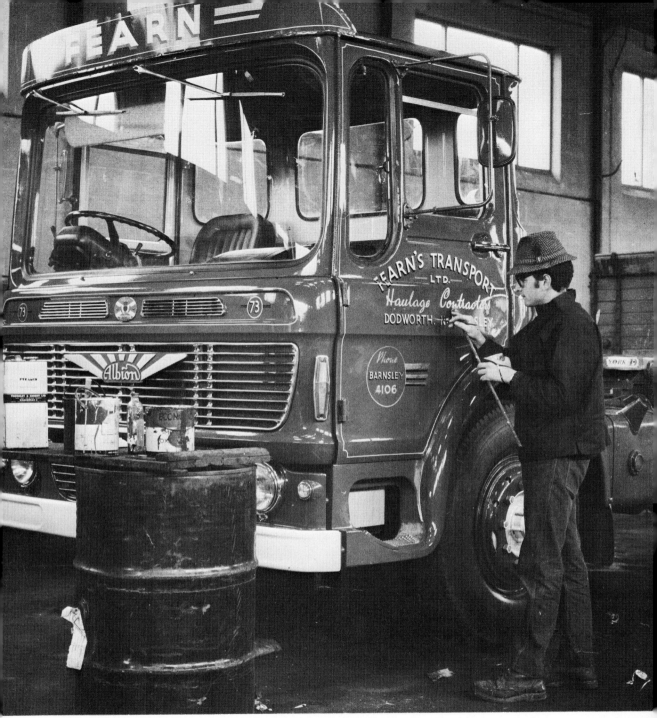

Working as a sign-writer

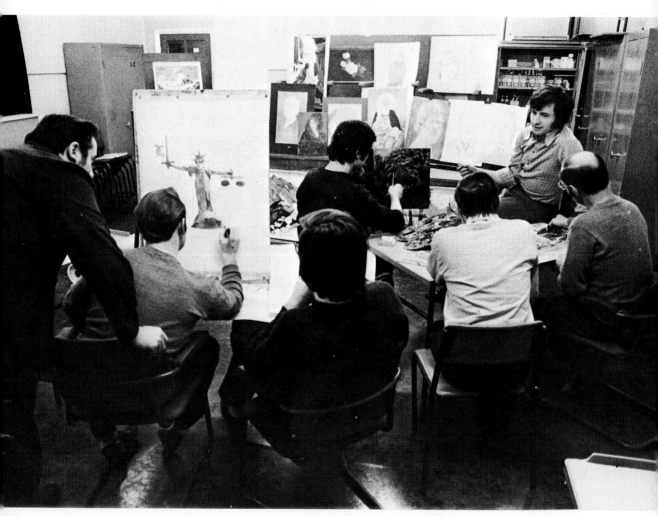

One of Ashley's art classes at Wakefield Prison,
where he taught for nearly eleven years

I remember being not very impressed by her argument.

The brothers were not very impressed themselves when they came to assess my educational standards. I still could not read or write with any expertise. Only at art did I excel.

The entire experience was hellish and short-lived. I was placed in a dormitory inhabited exclusively by upper-class Chinese boys, made to get up at five in the morning and take a cold shower before going on my knees for an hour to chant prayers in the chapel. The quality of the food was good but the quantity totally inadequate for my rapacious appetitite. Our guardians always appeared in clinically white robes and mixed love and discipline in equal proportions. They always had a sympathetic ear for a tearful boy missing his mother, but breaches of the rules were punished robustly. A Sam Browne military belt was kept hanging on the wall for this purpose.

I stood it for three weeks and then collapsed into a miserable sobbing heap. They could do nothing with me. In the end, the hapless brothers were obliged to summon my mother to take me away. Her anger was probably tempered by the fear that my intense distress might lead to a recurrence of the convulsions which had racked my infant life. So I went to live with her and my education continued at St Joseph's, a day school.

Mother and Aunt Ethel lived in Myah Mansions, a superior block of flats built over a row of shops in a tree-lined square. From the front window you could see St Andrew's Cathedral. Sonny Boy, Clive and sometimes my grandmother Scott came to visit, which made me happy. Their appearance always meant presents and exciting trips down to the Chinese quarter with my old companion from the snake hunting days.

Even at this stage I had never met Hedley Haigh. Obviously I was deliberately kept away from him, and there was good reason for this. Mother always had many admirers and it didn't bother me at first. In fact, I used to exploit the situation and receive a shower of gifts from the anxious swains. I later learned that before we left India for Scotland an American officer had desperately tried to marry mother and take us both off to the United States.

Mother always made me call her boyfriends 'uncle' and as I grew

older I began to resent them, sensing that they were competing with me for my mother's affection. Clearly, Hedley Haigh was a different proposition. She was not going to have that relationship ruined by a jealous child.

In the end, it took a serious accident which nearly orphaned me to bring me face to face with him for the first time. An ex-boyfriend had been driving my mother round Singapore when an Army lorry without lights smashed into them. He escaped injury but mother ended up in hospital. Grandmother Scott hurried down from Penang to take care of me and eventually I was taken to see mother.

There, sitting solicitously by her bedside, was this dapper man with a strange accent and a trim little moustache. It did not mean much to me at the time. Just another 'uncle', but he proved to be far more durable than all the rest.

Shortly afterwards, life erupted and I was displaced once again. Hedley Haigh's directors realised that this relationship with my mother was serious – probably confirmed by the car accident and the inevitable publicity – and in an attempt to break it up once and for all transferred him to another branch in Kuala Lumpur.

Mother promptly quit her job and followed in his wake, her somewhat bewildered son in tow. We were obliged as a result to live in what can only be described as a hut in one of the native quarters of Kuala Lumpur, not a very salubrious one, either. Our home had coconut leaves for thatching and alongside the street outside ran a stream, which was really an open sewer, because all manner of household refuse was tipped into it.

Her lover occupied a house provided for him in a more exclusive area.

Since my mother's income as a telephone switchboard operator had stopped, money was not as plentiful. But she had her army widow's pension and could still afford to pay a couple of teenage Chinese girls to look after me. It would have been necessary in order that she could carry on her courtship, the only reason we were in the place at all.

However I enjoyed the company of the young Chinese girls. They took me regularly to play around a local lake and would teach me to

50

sing Chinese songs, which I can still recall. I remember with even greater clarity a story which the elder of the two related to me more than once as they kept me amused during mother's absences. It was told in her slow and gentle sing-song way and it concerned a Chinese mother who had an only son. She spoiled him, gratified his every wish and gave in to every demand. When he grew up he became a notorious bandit and robbed and killed many people. But he was captured and sentenced to death, and on the day of his execution he was asked if he had a final wish.

He asked to see his mother for the last time. She was brought, and he embraced her emotionally. And then he bit her ear off.

During this period my schooling naturally suffered yet another setback. I was sent to the local village school, another hut but with a corrugated tin roof. There I was the solitary European among the Chinese and Malays and still very much bottom of the class. Apart from an ability to draw and colour I had scant scholarly accomplishments. Admittedly, I was not quick to learn but changing schools every few months did not help. But I had developed an ability to talk my way out of trouble so my artistic and conversational talents prevented me from sinking completely out of sight in the classroom.

I did acquire, however, certain knowledge which a more orthodox education would never have provided. Such as many basic Chinese and Malay phrases from my playmates and, more importantly, I learned how to handle a Chinese brush pen. All the local shopkeepers used them to do their customers' accounts, held vertically between two fingers. I observed them keenly for hours on end, fascinated at their speed and dexterity.

Today, people who watch me painting my watercolours are invariably impressed at the speed with which I work. Some accuse me of undue haste, but others who know better realise that the faster an original idea takes shape the purer it is. There is no doubt that I received my grounding in that technique among the peasant shopkeepers of Kuala Lumpur.

All in all, the year I spent among the working-class people of Malaya had many residual benefits. I learned how to cope with fewer of the

material things of life and a goodly measure of independence. Running around with the local lads forced me to be much more resourceful, improved my ability to cope with the challenge of life. There, I could not dash home to a protective grandfather or aunt. In fact, there was minimal adult supervision and I relished the exploration of swamps and bush and joined in the abuse everyone hurled when lorry loads of Japanese prisoners-of-war passed by. I became a local, able to swear fluently in three languages, and was accepted into the social structure boys create for themselves everywhere in the world. We had our own code of conduct and our own organised sports.

The principal activity involved a game which had certain parallels to conker fighting among British children, but was infinitely more exciting and bloodthirsty. By the sides of the open sewers grew a tree which thrived in wet and rancid ground. If you searched diligently among its branches you could always find two leaves neatly glued together. This was the lair of the fighting spider, a jet black insect about the size of a child's finger nail with distinct similarities to a crab. It had formidable pincers up front and short rear legs for speed.

Everyone had a stable of fighting spiders. They were kept separately in matchboxes – they had to be – and fed on live flies. Some would survive for weeks. Spider would be pitted against spider in carefully arranged contests. It was like cockfighting in miniature, with excited supporters crowding round the arena. Sometimes, fights would be silently organised at the back of the classroom.

These insects were really ferocious. They would rip each other's limbs off and every contest went on until one was dead. There were no quitters. Whoever owned the local champion, the spider with the most kills to its credit, was guaranteed an elevated status at school. Some rose to fourteen or fifteen victories, and gangs of boys clambered round the swamps seeking even bigger and fiercer spiders to challenge their supremacy. I had my own moment of glory with a beast that methodically massacred anything put before him. He retired undefeated just short of a score of kills: he collapsed and died one day, probably from exhaustion. Desperate attempts were made to keep champions alive and fit for battle, with offerings of rice, *satay* beef, anything we thought might please the palate of a fighting spider.

Memorable days. Even better than those I enjoyed in Penang with Clive and the snake baiting, and certainly more crowded. I learned a great deal during my year in Kuala Lumpur.

But the time came for me to be uprooted once again. My mother's affair with Hedley Haigh reached a critical stage. By then, everyone knew they were lovers – even the family in Penang – so they announced their engagement. Soon afterwards we all moved back to Penang. The journey was made via Singapore, where Hedley had some personal matters to attend to, and mother insisted on accompanying him. It meant a long haul, doubling back through Malaya where serious guerrilla warfare had broken out. The trains we travelled on had machine gun nests mounted front and rear, which I naturally found most exciting. I spent most of the time talking to the troops manning the guns.

It was not exactly a happy homecoming. I was glad to be reunited with grandpa and my cousins but there was a lot of tension in the air. We were a Catholic family and only a wedding would put things to rights. Uncle Ossie, a staunch believer, would not allow Hedley into his house until a marriage had been arranged.

Hedley's contract with his company ran out and it was not renewed. He announced his intention of returning to Yorkshire, declaring that he would take my mother with him and marry her when they arrived. Uncle Ossie would have none of it. He said he had personal knowledge of promises like that being made before – and not kept. If his sister-in-law was to leave Penang with Hedley it would be as a married lady.

The argument raged on between the two men. Hedley, an Anglican, protested that his family could not possibly afford to attend but the entire family joined in the chorus of insistence.

Hedley gave in, and named the day.

During the weeks running up to the ceremony, Hedley took me over. He was appalled that I could not swim and knew nothing about football and cricket. Particularly cricket! He said that if I was to go to Yorkshire as his stepson, all that would have to change. Back home he

had a brother not much older than me, so I would have to attain some skill in these activities or there would be nothing in common.

Not caring much for the idea and still somewhat resentful, I was forced into a crash course in sport, UK-style. Every afternoon we went down to the beach after school. No excuse was accepted. And sure enough he taught me how to swim. A football was purchased, bat and ball borrowed and I ran myself dizzy from dawn until dusk. I learned, alright. He was hard, but a good teacher. Praise was not lightly earned and slacking not tolerated. Towards the end of this exercise there was a significant incident.

Driving down to the beach one afternoon just before the wedding for a final swimming lesson, I started to cheek my mother who was coming along to see how well I had progressed. Warnings were issued, but I ignored them. Grimly, Hedley brought the car to a halt, leaned over to me and administered a good hiding.

It was to be the first of many.

Chapter Six

It was a Registry Office wedding and mother wore a page boy hat and a new cocktail dress, looking for all the world like an understudy for Rita Hayworth. All the family came and there was a reception at the Sea View Hotel, which overlooks the beach at Penang. Naturally, Grandpa Scott organised a band and it turned into quite a party.

Perhaps the second most uneasy person there was Hedley. Not because he had second thoughts about marrying my mother. His problem lay with his family back in Yorkshire. Quite apart from the upset of being unable to see him get married, they had become very suspicious about another matter.

They had begun to suspect that my mother was coloured!

The uneasiest guest of all was me. Mother re-marrying did not bother me – I had come to terms with that – but I knew that the inevitable consequence would be another uprooting. My experiences in Scotland were still fresh in my mind, and I was convinced that Malaya was the only place on earth for me. I was ten, old enough to realise that many privileges would be lost for ever and that I would probably never see my grandparents again, and possibly not even my cousins.

When the time came for the three of us to board the *SS Canton*, a P&O liner, I had to work hard to hide my abject misery. Grandpa Scott put on a real performance as the ship moved away from the quay. He brought his accordion and played non-stop until we were well out of

earshot. Tunes like 'We'll Meet Again', 'Cruising Down the River' and the rather emotional Malayan National Anthem drifted across the water, causing one man standing near us at the rails to complain that the occasion was hard enough to take without 'that old fool' playing songs like that.

And that farewell was to be my final memory of Grandpa Cecil Scott. We never did meet again, and he is long dead.

Clive and Sonny Boy stood with him, singing, calling out and waving. One of the messages shouted by Clive was 'Don't forget to send me some Yorkshire pudding!' It was something we had all heard about but never actually seen. Grandmother Claudia Scott gave me a Swiss watch as a parting gift, which I cherish to this day. Trouble was, I still could not tell the time, and reading was still partly guesswork. Exams gave me palpitations.

Logs were thrown over the stern again and off we steamed along a track with which I was already very familiar – the Indian Ocean, Red Sea and Suez Canal. The sun was so hot when we went through the Canal that the ship's crew were obliged to erect tarpaulin sheets over the deck to prevent sunstroke among the passengers. I was taught how to play table tennis by my new father, who one day announced that from then on I was to be known as Norman. He considered Ashley to be an effeminate name, not at all suitable for the stepson of a Yorkshireman. I did not object because it was the name of my real father. Mother had chosen my first name after she saw the film of 'Gone With the Wind' and fell for the character of Ashley Wilkes, as played by Leslie Howard.

For the first time in my life I was subjected to regular discipline. Hedley was stern to the point of being Victorian, but I know now that I owe him a great debt. It was painful, but he spared no effort in trying to make a man out of a spoiled brat. Mother played no part in this difficult process, content to let her new husband get on with the job.

The green slopes of the English coast emerged through a swirling summer mist. As we drew into Southampton a holiday cruiser passed by with its jovial, crowded passengers shouting and waving. And in the stern, a man playing an accordion. . .

Thus, the excitement of arrival was tempered by the image of

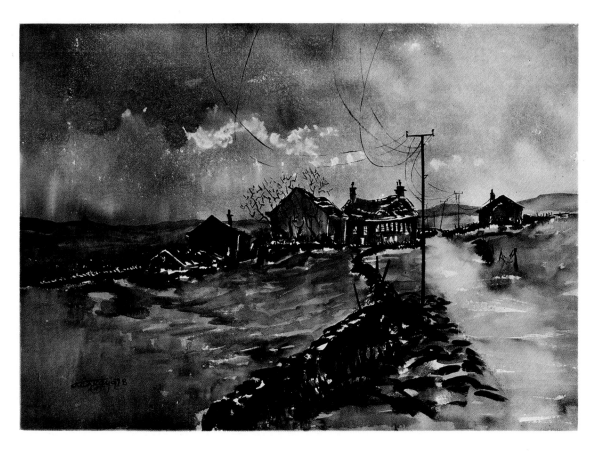

Hebden Moor, Yorkshire

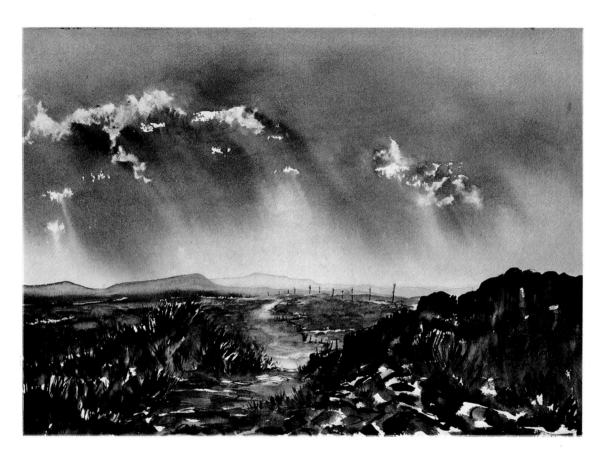

Greenfield Moor, Yorkshire

another accordion player now many thousands of miles away and my eyes filled with tears.

We travelled to London by train and stayed in a hotel for a couple of nights to await the disembarkation from the *SS Canton* of another important passenger – Hedley's much cherished car, a black bull-nose Morris Eight. He had acquired it in Malaya and would not hear of selling it and buying another in Britain. As we waited for the importation formalities to be completed we went to see the original production of the musical *Oklahoma!* To celebrate the occasion I was bought a cowboy outfit and marched round the West End wearing a large Stetson.

Despite the glamour of London, when I smelled the diesel fumes pumped out by the buses it brought back the memory of those two uncomfortable years in Scotland and I yearned for the aromatic air of Penang.

The bull-nose Morris finally emerged through the red tape and we quickly prepared for the final leg of the journey to this legendary land which Hedley had spoken of with such feeling.

Yorkshire.

Personal baggage was piled into the car – the rest of our belongings, packed in wooden crates, followed on later – and we drove up the A1. You could feel the excitement surging through the normally taciturn Hedley as we crossed the border into his homeland. It had been many years since he had last seen it, or his parents.

We drew up outside number forty-two Hazel Grove, Linthwaite, near Huddersfield. It was next to the end of a long terrace of houses and the front garden was full of white flowers, as though snow had fallen. Harry and Annie Haigh and young Malcolm, Hedley's brother who was just a year older than me, came rushing out. Mother and I stood back to watch the reunion and try and assess the new branch of the family. And then they turned to inspect the two of us, the bride their son had brought from the East and her child.

Harry Haigh, my step-grandfather, turned out to be a quiet and gentle person who was always kind. Annie Haigh was the dominant personality in that household and she and my mother never really

became friends. She was still worried that her son had married a 'native girl'. Apparently, when she first clapped eyes on my mother's swarthy Latin skin, burned mahogany brown on that long, hot sea voyage, she thought her worst fears had been confirmed.

Neither did my presence help, the constant reminder that mother had once been married to another man.

We lived with Hedley's parents for six months and it was for me one of the worst periods I have ever experienced. Not that it was the fault of the Haigh family, far from it. They treated me very decently and the friendship I formed with Malcolm persists today. The trouble was my education, or lack of it. I was sent to the local school where I was placed in a class taught by a man who believed very strongly in corporal punishment. He was, quite naturally, appalled that a lad approaching his eleventh birthday could neither read nor write with any fluency. With him, my aptitude for art and my gift of the gab cut no ice at all and he set about me with a ferocity I had never known before. The problem was compounded by his thick Yorkshire accent. I could scarcely understand a word he uttered. At the time, I spoke like a public schoolboy.

Nearly every day he dragged me out in front of the class to inflict punishment. Not with cane or strap, but with his hands and fists. I was so stunned and ashamed that I endured it silently, feeling that I could turn to no one – not even my mother, and certainly not my step-father.

In the end, two girls in the same class came to my aid. The Knight sisters could not stomach it any more and complained to their mother, who lived just a couple of doors away from the Haigh household. She told my mother, who went immediately to see the headmaster and kept on hammering on his door every time I received another good hiding. Margaret Knight was so concerned that she began to help me improve my English in the evenings and at weekends.

Not long ago, I was signing prints of my paintings in a Yorkshire art shop when the Knight sisters appeared in the crowd around me. Thirty years had passed since those painful days but I recognised them straight away and was glad of the chance to fuss over them and thank them again for that much needed support.

On the credit side, I had been accepted by the local children and had begun a life-long love affair with the uplands of Yorkshire. I shared a bedroom with Malcolm and at night would lie awake and gaze out of the window at the starlit hills. In Malaya there are no far horizons, only lines of trees or bushes in the near distance. When winter came, Malcolm introduced me to the joys of sledging which was a real revelation. We would climb high into the Pennines dominating Linthwaite and come surging over the frozen snow for five fields and more without pause, steering through the gates and gaps in the old dry stone walls. And together with Malcolm I joined the Boy Scouts and played cricket and rugby in the same team on Saturday mornings.

During our stay with the Haighs, Hedley was trying hard to establish himself in his native land. He secured a job in the office of the abbatoir in Huddersfield – not quite so grand as the position he held in Malaya but it did pay five pounds a week. Good enough in those days to run his car and pay his share of the household bills. The next priority was to establish his own household and he found a place only three miles away in Milnsbridge. It stood back-to-back with another terrace in Factory Lane, not the most desirable residential area around Huddersfield but it was ours. There were two rooms upstairs and one down, and a thirty foot wall loomed up across the road at the front. Going to the toilet meant a twenty-yard walk up a narrow back yard. There was only one for every two houses, so we had to share with five other people. A far cry from the houses mother and I had been accustomed to in Malaya, but for me it was better than a Maharajah's palace.

It got me away from the agony of that school in Linthwaite.

Now it was mother's turn to be put under intense pressure. She had never run a house without servants and senior relatives to lean on and many tears were shed as she buckled down to the task of becoming an ordinary Yorkshire working-class housewife. Hedley's mother had tried her best to instil into her some of the basic skills: how to scour doorsteps with a donkey stone (always given free by rag and bone men in exchange for worn out clothes and the like), how to bake, clean and polish brass, and above all how to make the legendary Yorkshire

puddings. (This delicacy came as something of a surprise to me – I had always imagined it to be a sugary dessert.) Mother had another, ever-growing burden to add to her discomfort. She was pregnant.

But for me, life improved rapidly. Terraced housing always produces plenty of children and I ran with the other lads in the area. There was never an empty moment. I learned all the traditional Northern street games and even improved my swimming prowess because we had our own heated outdoor swimming pool – of a kind. In one part of the 'cut', the local canal that ran near Factory Lane, the mills of Joe Hyman pumped out hot water after it had washed the fibres that went to make up his enormously successful Viyella fabric. The stuff was a trifle tainted but we came to no harm.

Hedley was still administering discipline in stiff doses. Whenever I transgressed the rules, there was no such thing as a quick clip round the ear and done with it. It invariably meant a good hiding. After a while, I could stand there and take it unflinchingly – like a man. And I know now that it was a man he was trying to make of me. On the other hand, he could also indulge me occasionally, particularly if it meant that it would help me keep pace with the other boys. For instance, he made me a splendid 'hurry' cart – called a bogie in other parts of the country – constructed from planks of wood and old pram wheels. I was able to take my place among the other lads as they organised somewhat perilous races down the local hills. Hedley made me hard: he wanted to see me up with the leaders of the local gangs. One of our favourite escapades was to break into Joe Hyman's mills by balancing on the pipes laid across the canal and climbing through the spikes put there to deter intruders.

Years later, I was commissioned to paint the very same mills I used to risk my neck entering as a kid. Mrs Hyman wanted the painting as a surprise birthday gift for Joe and one of his top executives took me onto the hills above to point out the required perspective and tell me about the area. He was more than taken aback when I told him how intimately I knew every brick in the place.

My traditional problems with education had eased slightly. I attended New Street School, a much more tolerant place than the last,

and joined the local Baptist church Boy Scout troop after obtaining special permission from the parish priest. Every Sunday I went to Mass with mother and was confirmed into the Catholic faith during my stay in Milnsbridge.

I took to Scouting with a will and quickly began to pepper my sleeves with proficiency badges. They made me leader of Cuckoo Patrol, which boosted my image at school. It turned out that I was following in illustrious footsteps. Those of Harold Wilson, no less. When I first met him he was presenting paintings of mine to a group of Yorkshire members of parliament to mark their elevation to the House of Lords. Afterwards we talked about our respective boyhoods in Yorkshire and I discovered that he, too, had lived in Milnsbridge, attended New Street School, joined the Baptist scouts and risen to leader of Cuckoo Patrol!

Art was still my saving grace at school. The Pennines of Yorkshire now held me permanently in their grip and I tried desperately to paint them effectively. Hedley, in one of his generous moments, bought me a better paint box but the effort to turn the daubs into real paintings was almost as traumatic as learning to read.

By then I knew for sure where my future lay. Not that it was a major decision. At every other academic pursuit my efforts were still like trying to swim through treacle. But every other aspect of life was going well for me. I was settled.

That state was not to last for long, however. Along came Fate once more to turn my world upside down. It was an attack on two fronts. Geoffrey Haigh was born, and Hedley managed to win a new and prestigious job as the manager of Barnsley Abbatoir. That meant we had to move house again.

It was natural that the baby should harvest most of the affection available in our household. He was, after all, their very own baby. But life definitely changed for me after Geoffrey's birth and I must admit to a certain amount of resentment. We took a house in Longman Road, Barnsley, which was a big step up the social ladder. No more back-to-back existence as in Factory Lane for the Haigh family. The new place was a spacious Victorian semi-detached. It had one drawback – only

two bedrooms. Hedley and my mother shared one, baby had the other.

I was given the attic.

The isolation was painful at first, and so was the cold during the winter months. My breath came out in steamy white clouds. Eventually, I grew to like the independence a room on a separate floor from everyone else gave me. I could disappear and enter my own world to dream the dreams schoolboys have about their future. I could also get on with my painting in peace.

After a brief and discomforting period of adjustment, Barnsley and Ashley Norman Jackson took to each other. For the first time in many years I was able to put down roots.

They are still firmly there.

Chapter Seven

I never did sit the eleven-plus examination, which was really a piece of luck. The differing local rules said I was too young when my faltering education was administered by the Huddersfield authority and too old by the time I arrived in Barnsley to enrol at Holyrood Roman Catholic School. Thus, I was spared the ignominy of total – and public – failure.

There were other, more physical tests to face at my new school. Holyrood was the toughest in the entire Barnsley area. Years later, when I began to teach art to the prisoners in Wakefield Jail, I discovered that eight of the 'lifers' were old boys of Holyrood.

The school was part of a large Catholic complex. The junior and senior schools were joined to the church and the posh, fee-paying convent school to form a square. And in that blessed plot, all human life flourished. I started off in the junior school and Hedley had done his best to smooth my path. He had talked to my teacher and arranged for a lad called Hugh Thorpe, a fellow pupil who lived nearby, to call for me on my first day.

And a climactic first day it proved to be. During the morning break when I was staring round trying to digest my new environment, Hugh strolled over and announced casually that I was fighting at dinner time.

'Fighting! Fighting who?'

'Him over there. Paddy Heavey, the cock of the school.'

He pointed to the roughest looking lad in the schoolyard. He had close cropped fair hair, resembled a fairground boxer in miniature and he was scowling malevolently in my direction.

'Why?'

The word was half-strangled by my rising panic.

Hugh patiently explained that it was the accepted tradition. They did not get many lads entering half-way through a year at Holyrood and Paddy needed to confirm his status as cock of the school. I was a threat, you see. An off-comer. There was no getting out of it.

He was right. There was absolutely nowhere to run to. I went through the rest of that morning's lessons in a trance. Came the appointed hour and I was led out to the corner of the playground farthest away from the view of the teachers. The entire school had turned out to watch and they gazed at me in gleeful silence as my leaden feet took me into the centre of a rapidly forming circle of Paddy's supporters. My opponent was rolling up his sleeves in a theatrical manner.

I suppose the preliminaries to these juvenile blood sports are all the same. No one really wants to throw the first punch. A chorus of encouragement came from the onlookers, eager for the performance to start, which turned slowly to derision and taunts at the lack of action. Paddy was snarling at me to get on with it, I was rigid with fear. His supporters began pushing me in the back repeatedly, forcing me closer and closer to their champion. I will never know why – perhaps some deep, basic reasoning told me that in this situation valour was the better part of discretion, or perhaps my gipsy blood could stand no more of the taunts – but suddenly I flung myself on Paddy and we both crashed to the ground.

This move brought a howl of appreciation from the audience. The fight was on in earnest, and it promised to be a classic. I think it lasted most of the dinner break. And there were no pulled punches – it seemed to me to be a fight to the death. My memory now recalls it in slow motion, of knuckles pounding into my head, wrestling in the dust and muscles straining to shift his arms as they locked round my head.

The outcome was inevitable since he was much stronger than me. But I knew how to take a beating – my stepfather had seen to that. Eventually he pinned me to the ground. I was almost too exhausted to avoid his blows by then. He knelt on my chest and raised his fist . . . I

closed my eyes and concentrated on fighting back the tears. There was a long moment, and nothing happened. The blow never came. Instead he jumped up, hauled me to my feet and said:

'What are we fighting for, lad. I don't even bloody know thee!'

Apparently, honour and tradition had been satisfied. He even shook hands with me before I tottered away to lean against a wall to recover before lessons began. News of the combat had reached the staff room by then and a senior master hurried out to issue warnings and obtain confessions. But there were none to be had, for to grass was the worst crime of all at Holyrood. The master looked at my bruised face and dishevelled clothes and shook his head sadly. From then on, though, I was accepted into the Holyrood mafia. I even came under Paddy's protection, for he issued an edict that anyone who harmed me would have to deal personally with him. But if I had shed a tear during that encounter I would have been a target for every bully in the school. That was the key.

As it happens, it was a damn close run thing.

It is probably true to say that my years at Holyrood were the most character forming of my life. I went there with a curious, unsettled background, speaking with a fancy accent and secretly nursing a desire to be an artist, and was plunged into a survival course. There were no compromises at that place, which drew its pupils principally from coal mining and other basic, working-class stock. If you showed weakness, or admitted to something as peculiar as being called Ashley you would sink without trace. I was known as Norman Jackson and took great care to hide everything else, including my artistic ambitions. I felt sorry for Hugh Thorpe, son of a music teacher. His sole aim in life was to be a musician – which he now is – and he had been told that his chances would be seriously diminished if he broke his fingers. Since fighting was a way of life at Holyrood he spent a lot of time worrying himself silly about the consequences of being forced to accept challenges from the hard men of Holyrood, one of whom went on to box for England.

To my astonishment, I began to progress smoothly up the ladder at that school, both in the playground and the classroom. We sat an

examination to grade us upon entry to the senior school and I went into the 'A' stream. Not the 'B' or the 'C', but the top class. Nothing like that had ever happened to me before.

At this juncture, I came under the benign influence of Miss Gertrude Young, a teacher to whom I shall always owe a debt of gratitude. Under her inspirational guidance I was given a classroom confidence which was blissfully new to me. To begin with I struggled near the bottom of the class – twenty-eighth to be precise – and I was paraded in front of Oswald Livesey, the headmaster, and threatened with demotion unless there was a dramatic improvement. But Miss Young took a special interest in me, gave me after-school tuition and I soared quickly to fourteenth position and safety.

I also prospered outside the classroom because I was reasonably good at sport, particularly swimming. I was in the school squad and Holyrood was good in competition, largely because we were feared by every other school in town. Any sporting occasion was conducted with the utmost violence, particularly the ball games. We reserved a particular hatred for the Barnsley Grammar boys. And long before the 'Blackboard Jungle' era started, we had a case of a boy beating up a teacher.

Eventually, I felt secure enough to express an interest in art. Miss Netherwood, the Art Mistress, was only too pleased to find pupils willing to work diligently at her subject. Two of us began to stay behind after school to take extra lessons. My sole companion was called Tony Daley, and he went on to become an art teacher himself. When I was thirteen, the school entered a poster of mine in a Road Safety art competition and we won it! I even went on to become a prefect – indeed, I ended up as Head Boy.

They were truly formative days. When I emerged from Holyrood School I was ready to face anything that life could throw at me. My BBC accent had gone for ever, and the simple working-class ethos that anything worth having would be taken away from me if I did not fight for it, was ingrained forever.

In essence, that school made me a true Yorkshireman.

The major flaw in my life in the latter days at Holyrood lay at home. My mother and my dad – and I did call him dad – had little time to spare for me. Babies are demanding, I realised that – and mother had two more at Longman Road – but I was hurt when neither my mother nor Hedley turned up to see me winning glory for the school at swimming galas. Hedley also imposed a discipline which interfered seriously with my social development. I had to be in at night hours before any of my mates. When I was fifteen the curfew hour had been extended only to nine o'clock and most of the early part of the evening was swallowed up by evening classes. Even more crucial was the question of dress. They would not buy me long trousers, however much I pleaded.

Hopefully, I would sit with the others under the corner street light to talk about sex and ogle the local talent. But none of the budding, adolescent girls who came into our orbit would spare a second glance for a gangling lad in short trousers. Most Saturday mornings meant trips to the local cinema matinée – seats cost six old pence – and I was usually the odd one out in the gang. I yearned to be like Tony Daley. He smoked, dressed like Frank Sinatra in long trousers and a trench coat and had all the girls flocking round. I used to hang about hoping. At the time I was desperately in love with a ginger-headed girl called Janet McPherson, but I doubt that she ever knew. I regularly walked miles just to be able to say 'Hi!' to her but my faltering suggestions that she should sit with me in the cinema were scorned.

There was another sartorial crisis when Hedley's mother bought me some boots. I was still friendly with Malcolm, Hedley's young brother, although Mrs Haigh regarded me vaguely as a bad influence because of my Holyrood background. But she was usually kind, despite her habit of introducing me as 'Hedley's step-lad', and an expert at picking up useful things at jumble sales.

One day she found some fur-lined, zip-up boots which she handed to Hedley, saying they would be ideal for me in winter. Trouble was, they were girl's boots. I could not possibly turn up at the street corner evening conferences wearing girl's boots, and point blank refused to have any truck with them. Naturally, there was one hell of a row.

All I wanted, nay, longed for, was a pair of long pants but I was made to wait until I had left school before I was finally granted this

vital symbol of manhood. And then they were jeans.

Not that we were that short of money. Hedley's job paid him enough to afford to go rallying in an MG, and he also ran a brand new Volkswagen and an A35 van. Mother had a war pension of eleven shillings a week until I was sixteen – a significant sum in those days – and each Christmas she received a lump sum from the money paid by the Japanese in war reparations. Indirectly, therefore, I did make a contribution to household expenses but that did not bring me any special privileges. They did give me a bicycle on my fourteenth birthday, bought second-hand for five pounds, but personal pocket money was scarce. I had to ask for anything I wanted since there was no question of a regular allowance. On the other hand, there were more mouths to feed. Mother gave birth to another two children, both girls. By then I had come to terms with being something of an outsider in the family. I was very fond of my little half-brother, Geoffrey, and frequently took him out to play. But those were nerveracking occasions, because if he fell or hurt himself in any way whilst in my charge there was the devil to pay.

When I left Holyrood at the age of fifteen, all I wanted to do was win a place at Barnsley Art School. But that meant passing an examination. The old psychological barrier was still there and, anyway, I knew the standard required was beyond me despite my improvement at school. But Mr Livesey, Holyrood's head, and my art teacher, Miss Netherwood, sprang to my aid. They gave me glowing references. More importantly, Miss Netherwood – bless her – had kept every one of my drawings, sketches and paintings from when I first started at the age of eleven. A portfolio crammed with every kind of attempt at art. They presented it to Mr Harry Glover, the Art School principal, who proceeded to examine it carefully.

And I was in! Accepted immediately without being obliged to suffer the agony of an examination. Time and again, my art was to rescue me from a life of drudgery. Elated, I flung myself into every course available, which ranged from fine art to sign-writing and commercial painting and decorating. Yet, oddly enough, I did not stay there long on a full-time basis. Before I made sixteen, I heard that a sign-writer in

Barnsley was looking for an apprentice. I went home, told Hedley and before long was being looked over by a man called Derek Harley. It was agreed that I should work for him and continue my education in the evenings, which I did – five nights a week until I was twenty-two.

My employer insisted that all those who wielded a brush for him should be impeccably turned out. I had to be attired in shining white overalls, and an apron with a kangaroo pocket to keep them clean. Boots had to be highly polished. The night before I started Hedley drew me to one side and, with some embarrassment, talked about the possibility of 'funny business' from the other workmen. That they might try to force me to submit to an initiation ceremony, and I was to tell him if they did. I had no idea what he was talking about.

Next day I proudly reported for duty at a building site which swarmed with all kinds of trades – bricklayers, plumbers, electricians, the lot. And when they heard that it was my very first day at work, they pinned me to the ground and ripped off my trousers. They painted my penis with pink emulsion and coated my testicles in thick varnish.

The emulsion washed off easily but I had to shave off my pubic hairs before I could rid myself of the varnish. Not one word did I say to Hedley, and I threw my underpants away to hide the evidence.

I was supposed to be an apprentice sign-writer but I did not lay a hand on a brush for a long time. Like all apprentices in those days, I was given all the lousy jobs such as scraping muck off guttering and downspouts to prepare them for painting. I was paid two pounds a week, worked like a black and came home most nights with my white overalls smothered in filth from top to bottom. It was pure misery.

Even though I was bringing home a wage, Hedley still refused to let me keep it. I had to hand it all in and carry on the old system of asking for extra money when I needed it. After a year, the firm ran out of jobs and I was given my cards. So I trailed back to the Art School where Mr Glover was kind enough to take me on again as a full-time student until I could find another job. At that stage, it was sign-writing that fascinated me and I trailed all over Barnsley trying to persuade somebody to give me a job as a trainee.

And then I heard about Ron Darwent. Other painters and sign-

writers talked about him with grudging admiration. He was the best for miles around, always worked on his own and never ran short of work. A real artist, a master of his craft. I tracked him down and persuaded him to let me watch him at work. They even gave me time off from classes at the Art School so that I could sit there and marvel at his expertise. He was very reasonable about this, until I began to hint that he might need an apprentice. And then to plead openly with him to take me on. For a long time he would cut me short, saying he did not want the pressure of a ham-fisted lad working for him. He was very content to carry on solo. But I kept at it, bring examples of my own attempts at sign-writing to show him.

It took a long time, but one day, as I launched for the hundredth time into the wonderful benefits which would accrue from hiring me, he flung down his brushes, swore violently and declared:

'Alright lad! Alright! You can bloody well start tomorrow!'

It was a forty-eight hour minimum week, with plenty of overtime and Saturday morning work, and the pay was one shilling and one penny per hour. And I loved it. The first brush I learned to use as Ron Darwent's apprentice was a sweeping brush. Every morning I had to arrive at his studio an hour before him and clean the place out. But he also set up a practice area for me and for part of that hour I could use his gear to try and learn, choosing one letter and doing it over and over again until it was good enough to earn a nod of approval from the boss when he came in.

I had my own key to his studio and he allowed me to open his post, a responsibility which I relished. Shortly after taking me on, he even invited me to be a guest at his wedding. He would talk to me as though I was almost an equal, listen patiently to my problems and ambitions and in the end became a kind of father figure. I badly needed someone like that to relate to since communications with Hedley failed to improve in any way. By then, he had started to alternate good hidings with an even worse punishment: confinement to barracks. I was still, at the age of sixteen and a wage earner, made to be indoors by nine o'clock at night. If I transgressed, I was not allowed to go out for pleasure for a specified period – up to a month if his mood was

particularly foul. I could go to night school, but visits to the cinema and youth club at weekends were banned. Mother would take pity on me and sometimes allowed me to slip out if Hedley was working late or car rallying.

Ron Darwent's studio became my haven, almost a place to hide. I was an eager pupil, terribly anxious to please and under Ron's tuition progressed rapidly. He himself was able to do anything in the sign-writer's repertoire with nonchalant ease. Simple board work, lettering vans and coaches, even glass gilding, which was the most difficult to learn.

By nature, sign-writers are philosophers. They spend so much of their working life alone, often above the heads of the passing public on scaffolding, that they have time to think. Ron was in his thirties when I met him and he quietly realised that I needed help over and above that of learning how to be a sign-writer. His pleasure was to hike the moors or go rock climbing at weekends and he began to invite me to go along with him and his mates.

It was a revelation to me. I had long known and loved the uplands close to my various homes in Yorkshire but I had never had the opportunity to venture far. Ron took me to the really remote and spectacular parts of the Dales, and I was mesmerised by their enormity and sullen beauty.

He would listen in amusement to my youthful declarations that one day I would be an artist and this was the place I would paint. But he took me seriously in the end, and one day handed down some advice which made a lasting impression.

'Alright, lad. If you want to be an artist, then be an artist. But remember this. Go all out for it. Do it properly. Don't play at it.'

Chapter Eight

Before Ron Darwent gave me his shoulder to lean on, there had only been one other person who took a genuine interest in my hopes and fears and future – but only on an all too brief, annual basis. A figure from the distant past.

By the time we moved to Barnsley, mother had re-established regular communication with her first mother-in-law, Grandmother Dolores in Limerick. Grandma very badly wanted to see me again and persisted so much in her letters that in the summer of my twelfth year it was arranged that I should spend the entire six week school holiday with her.

The journey to Ireland was remarkable. I was placed on a kind of ecclesiastical conveyor belt. Mother delivered me to the convent next to Holyrood School and the nuns took me to a convent in Leeds. In turn, they deposited me in Liverpool where more nuns escorted me on to the night boat for Dublin.

But once on board I was basically abandoned, and what followed proved to be a vivid contrast to the serene progress we had made overland. The ship sailed at ten o'clock and all the nuns retired to their first-class cabins. But I had been bought a steerage ticket. Sitting alone at the stern of the boat I witnessed scenes of depravity I had never dreamt of before. The bar was crowded with roistering, drunken horse dealers and returning navvies, the lounge was a rugby scrum and in quieter corners of the decks couples were busily making love. It was certainly no place for a nun. I did my best to sleep on a life raft,

completely bemused by the Bacchanalian orgy surging around me. Quite an experience for a twelve year old. In all, I made the same journey five times. It did not change much.

In Dublin, the nuns handed me over to the Children of Mary, who in turn passed me to a lady who took me home and gave me a meal. She then escorted me to the railway station and placed me on the train for Limerick. It was a long journey and I sat there alone, wearing my school uniform and sandals, watching the scenery go by. The nuns had told me on the way that in Ireland the grass was greener than anywhere else in the world and so it seemed to be. I had one minor panic when the train reached somewhere called Limerick Junction, which was miles away from the place I wanted to be, and began to go backwards. I thought I was on my way back to Dublin, but it turned out to be a loop line.

As the journey ground on, I tried hard to bring to mind any image of my Spanish grandmother. But none came. It had been six somewhat eventful years since I had said farewell to her in India and that is too long to sustain a memory in a child's mind.

When I stepped from the train in Limerick, my nostrils were assailed by a pungent smell. In my sensory system, the nose has always been well to the fore and there happened to be a large bacon factory near the station. The consideration of this curious odour was interrupted by the shrill cries of a bird-like woman, even smaller than me, who was bearing down on me at a rate of knots.

'Norman! Norman!'

She had recognised me instantly. Just before she clasped me to her bosom, she stared intently into my eyes and declared: 'You are just like your father. Oh Norman!'

Norman Valentine Jackson. I had not thought of him for a long time but the mention of his name unleashed a flood of memories. And tears, for both of us, small boy and elderly lady, standing on the platform of Limerick Station.

When the emotion subsided, we embarked on a memorable progress through the streets of Limerick. We walked all the way to her home in Wolfe Tone Street and my impending arrival had clearly been well

advertised. All the way she continually hugged and kissed me, dragging me into shops and houses to exclaim:

'This is him! Norman. My boy's son!'

I had not known such affection, not for as long as I could remember. And it was most welcome. When we arrived home I was embraced for the twentieth time that day, this time by grandma's companion, Mamie White. Aunt Mamie she became to me from then on. Grandmother Dolores had gone to live with her after a bitter dispute with the girl her wayward elder son, Raoul, had married. She cordially detested her from then on. As for Raoul, he had completely disappeared from Limerick and no one knew his whereabouts.

Limerick was wonderful, the place and the people. I was flung headlong into a warm bath of love and furious activity. In and around Wolfe Tone Street, life pivoted on the family and the Roman Catholic Church. On my first night, grandma asked me how long it was since I last made confession and was appalled when I told her. First thing next morning I was hurried into the confessional box.

But it was a different set-up to the one I had known in Barnsley, where you always had the individed attention of a priest. In Limerick, it seems, people had so many sins to get off their consciences that priests heard them two at a time! I started to gabble as soon as I entered the box, 'Bless me father, for I have sinned. . .', launching into a list of transgressions which usually centred around erotic thoughts and masturbation.

At this juncture back home, I was usually urged to play more football or take a cold bath. But to my utter amazement, the priest burst into uncontrollable laughter. Apparently, he had been trying to concentrate on the sins of the person in the next box when these unlikely confessions recounted in a strong Yorkshire accent came floating across. The comedy of the situation had proved too much for him, for he was a very jovial priest – as most were in Limerick.

I went to Mass every Sunday that holiday. Back at Holyrood I had graduated to the position of altar boy and when that merry priest found out he allowed me to assist with the intricate ceremonies of the Holy Catholic Church, a great honour which pleased grandma no end.

Limerick was a different world, and heavily populated. But every-

one had time for you, personally. One of Aunt Mamie's relations was called Willie Hurrigan, who made a living as a diver walking around the bottom of the sea in Limerick docks in the old style copper knob suit. He was a prodigious man in every way. He lived in a three-storey house near Limerick jail where he and Mrs Hurrigan raised twenty-two children. Twenty-two, all living! I just could not believe that household, but I loved to go there because life with the Hurrigans was tremendous. Even with all his distractions, Mr Hurrigan still found the time to play draughts and chess with me.

Back home in the evenings with grandma and Aunt Mamie, I sank blissfully into a cocoon of affection. I listened to the stories she related, of how she had been sold as a child, of Flamenco dancing round the world, of the famous people she had met, of the good old days in Singapore. And she talked to me often of my father, telling me what a marvellous man he had been and how terrible his end. Her favourite son. And over and over again she told me how much I resembled him. The eyes, the hair, the mannerisms, everything!

She spoiled me and I lapped it up. I was even allowed to stay out playing in the street with my new mates until nine o'clock at night, a three hour extension compared to the Barnsley curfew at that age. Willie Hurrigan, junior, became my special pal. Enormous gangs of local kids would walk out into the surrounding countryside to play. Some of them padded along in bare feet because Ireland in the fifties had a very poor standard of living.

Our favourite place was a section of the River Shannon six miles out of Limerick where the current was suitable for swimming. I was in my element because swimming had been my favourite sport ever since that crash course from Hedley Haigh in the sea off Penang. My status in the gang improved no end when they watched me plough through the water from one bank to the other.

And so the summers of my puberty were spent in this glorious fashion. Every July I turned up in Limerick to find that nothing had changed, and every September I was returned to Barnsley with a heavy heart. In Ireland I was accepted unreservedly by everyone, and my grandmother was at the centre of it all. I think I could have settled there happily. On one visit I was granted the special honour of serving

at the Nuptial Mass of one of the Hurrigan girls. The bridegroom came from Dublin, and he slept in my bed the night before the wedding.

Together with Willie Hurrigan, I roamed the countryside from dawn until dusk, helping with the haymaking, messing around with horses, lending a hand in the potato fields, trying my first sip of Guinness and laughing a great deal.

It was there that I kissed my first girl. She was blonde, beautiful (to me, at least), quite a bit older and called Patsy. I never knew her surname. She pressed me to her bosom behind a haystack, and who knows what might have happened had Willie and his mates not discovered us. I was just beginning to appreciate the succulence of a lover's kiss when the spell was broken by the sound of inane giggling. My virginity was to remain intact for years to come.

A different world, indeed. The pubs stayed open all day, the women went around in black shawls, and the wearing of a cap back to front meant you supported the IRA. When the sun went down I listened to the Hurrigans recounting the recent bloodstained history of Eire. How terrible the deeds of the Black and Tans seemed, and how tuneful the rebel songs sounded in those far-off, blissful days of my Irish summers.

But the time came when my annual escape route across the Irish sea was blocked for good. The costs of travel had risen and Hedley refused to meet them, a decision that really hurt me. I was rising sixteen, but how I missed my Spanish grandmother.

For the next couple of years, the only adult I could turn to was Ron Darwent. When my training was over I went about Barnsley lettering doors, delivery vans, pub windows, gable ends, anything and everything. I improved to the stage where I, too, could look down at the passing parade of humanity on the street below my trestle board and ponder on the meaning of life. But I had one fatal flaw as a sign-writer. Spelling. I was hopeless at spelling, a legacy of my continually interrupted education. It led to several unfortunate incidents, which tested my employer's patience to the limits.

In retrospect they are funny, but no one laughed at the time. One of the more memorable happened when the manager of the local branch

of Woolworths came to the studio to arrange promotional material for a big sales drive. I was given the task of designing two posters, each saying 'Spot the Mistake in the Window! Valuable Prizes given away FREE!'

I got cracking and delivered them within hours. They were placed immediately on either side of the store's main entrance. Next day the manager came back brandishing the posters, his face red with anger.

'You've cost me a bloody fortune. Half the town's been in, demanding a bloody free prize. Just look at that!'

We looked. I could not see what was wrong but Ron visibly cringed. 'Valuable' had been spelled 'Valuabel'. A client was lost, and a valuabel one at that! But Ron was so good that we could scarcely cope with the work offered to us. Overtime at night was commonplace because lorries and vans were invariably lettered after working hours so they need not be kept off the road by day, and the weekend seldom started for us until one o'clock on Saturdays. But we never worked on Sundays. Ron said that no one could afford to employ him on Sundays.

Some weeks I clocked up sixty-four hours and would take home more than three pounds and ten shillings, old money. I still had to hand over every penny and no argument would persuade Hedley to let me keep most of it as a regular allowance until I was nearly eighteen. I just got a few shillings spending money. Most of my friends were given the privilege of managing their own finances before me and could save for trendy clothes and splash money on the girls. In my early teens the only attribute I possessed when it came to attracting girls was an ability to bop with the best.

Oddly enough, it was my mother who taught me how to dance in the modern fashion. We would practise in the kitchen for hours, but only when Hedley was out. She obviously retained the old urge to dance the night away as she used to in the days of Malaya and India. Mother never stopped loving me in her fashion and tried her best to redress the harsh treatment I endured from my step-father. But she rarely, if ever, took my side in any of the rows. I assumed that she dared not.

Around this time, another figure from the past entered my life for a

brief but very educational spell. He just turned up on the doorstep one day – Clive, mother's young brother, with whom I played truant down by the river during our two years in Scotland. He had spent some years in the Merchant Navy, had visited all kinds of exotic places and was so knowledgeable and sophisticated. I was allowed to show him round Barnsley, and he in return opened new vistas for me. Particularly those concerning the opposite sex. I listened keenly to tales of his exploits in the bars of South America and the Far East and observed carefully as he went about the task of pulling the Barnsley girls. But some of the finer points in his flow of sexual patter did escape me at first. I well remember how he would walk down the main street of Barnsley eyeing up the girls and saying in a slight American accent: 'Would you just look at the lovely arse on that one!'

I was at a loss to understand how a female bottom, or any bottom for that matter, could be classed as lovely. But I learned.

The other benefit he conferred upon me was sartorial. I got his cast off clothing. Up to then I had never possessed any classy gear to help attract the girls. He gave me a wonderful, white sharkskin bomber jacket and a silk jockey jacket with 'Singapore' written across the back. Never before had I cut such a figure at the youth club.

Clive lodged with us and declared that he was finished with the sea. He wanted to settle down and get a steady job. Mother helped find him a place at the pit. So one Monday morning, he strode off purposefully to Barnsley Main and descended to the coal face.

He lasted six hours. When he emerged he swore long and fluently as he batted the coat dust out of his clothes and declared: 'That place is like a concentration camp. I have never worked so hard in my bloody life. Even blacks don't have to sweat like that!'

Clive went straight back into the Merchant Navy and I was sad to see him go. He had been a revelation, given me a glimpse of a much fuller life. And he left me with a new resolve. When I was rising seventeen, a group of my friends announced that they were off that summer to spend a week at Butlins in Filey. I listened as electrifying stories were exchanged of the debauchery to be enjoyed by one and all when night fell over those chalets set by the side of the iron-grey North Sea. Girls were alleged to fall into your arms on demand. But it was going to cost

around fifteen pounds if you included a bit to flash around for the girls. A fortune!

Normally, I would have considered an appeal for such a sum as a waste of time. But fired by the influence of Clive, I launched a long and bitter campaign at home until, to my astonishment, they conceded. It was my mother who clinched it because, unknown to me, she had put some savings from her cigarette money into a Post Office account for me. Hedley grimly marched me down to the GPO to draw out the fifteen pounds. I was enormously grateful to him, being under the impression that the money was his although I did wonder why I had to sign a form before we could have the money. He failed to tell me that it was legally my money.

Butlins was superb, but the great moment I lusted for did not come about. I danced the week away and teamed up with a girl called Ruth to win the jiving competition. Rubber Legs Jackson they called me. But all my chat-up lines so assiduously learned from Clive were utterly wasted on Ruth. She was engaged to a boy back home who had not been able to come with her and she was determined to remain faithful to him. Our association was strictly confined to the dance floor.

All my mates claimed they scored every night. Perhaps. I suppose if the chance had been presented to me I would not have been able to cope with it. Compared to them, I seemed light-years behind in the delicate business of mounting a successful assault on a girl's virtue. So I returned to Barnsley with no spectacular sin to confess at my next audience with the priest, back to the familiar round of days spent sign-writing and nights studying at art classes and jiving at the youth club. Bop was my great passion and I teamed up with a lovely girl called Dolores Nightingale at the club. Together, we won many competitions, travelling at weekends with the Holyrood gang to places as far away as Blackpool to dance against other youth clubs. We also formed a skiffle group, Lonnie Donegan style, and I played guitar.

But I was still an innocent. I recall going to stay with Malcolm Haigh one weekend and organising an all night party. Just Malcolm, me and two girls. With illicit bottles of Newcastle brown ale. We sat around

until six am, playing records, strumming guitars and passing the beer round.

We may have thought a lot about it, but neither of us even tried to lay a finger on those girls. They were both probably disappointed because they never came again. But we really did not know how to start.

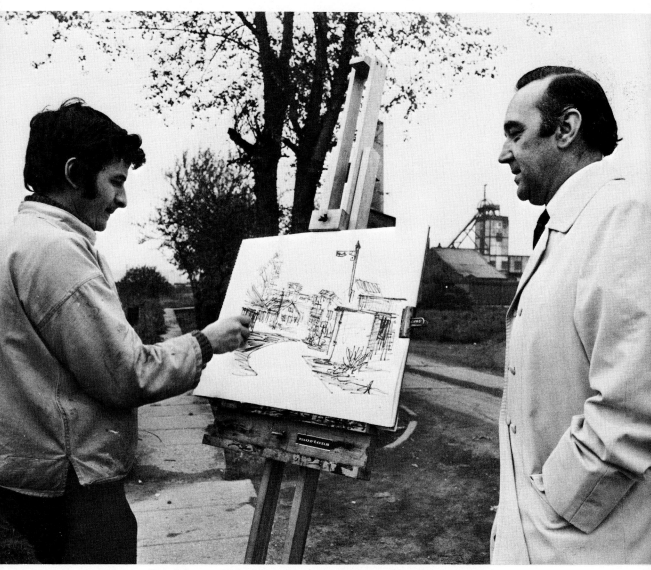

Roy Mason with the artist as he sketches the MP's old pit,
Wharncliff Woodmoor 4 and 5

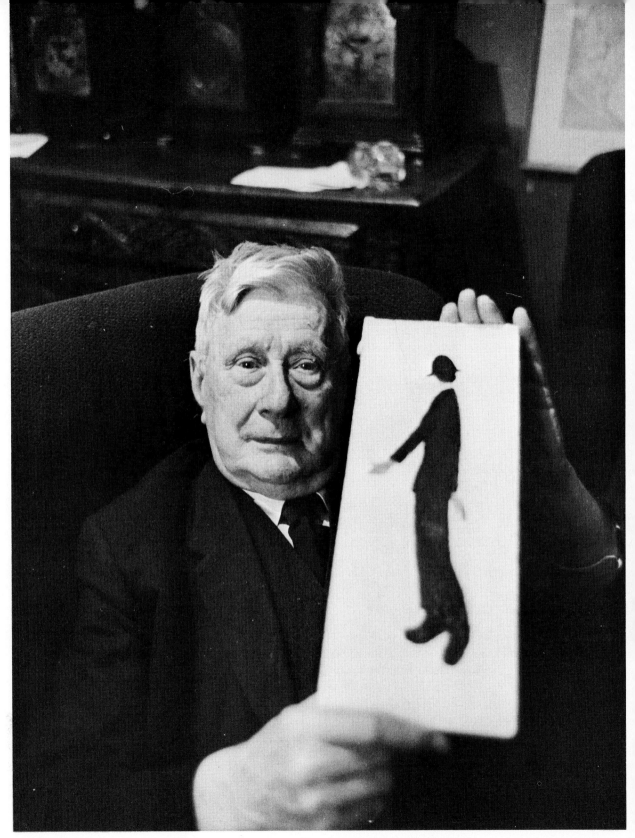

L. S. Lowry with one of his famous 'matchstick men'

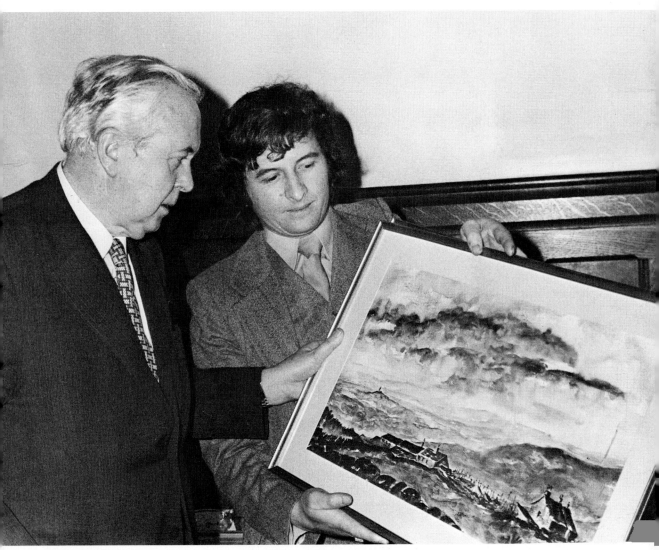

Ashley with the then Prime Minister,
Harold Wilson

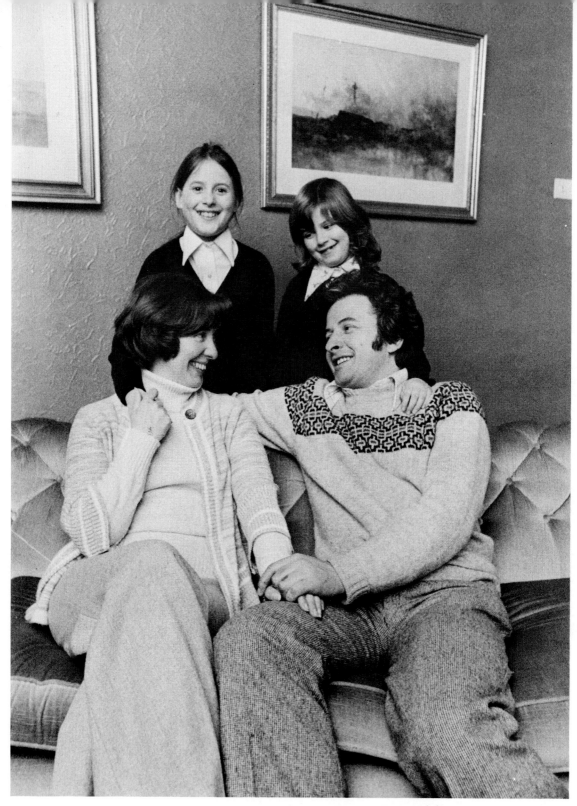

At home with wife Anne, and daughters Heather and
Claudia

The Rodriguez Rey family: Ashley finds his gypsy roots

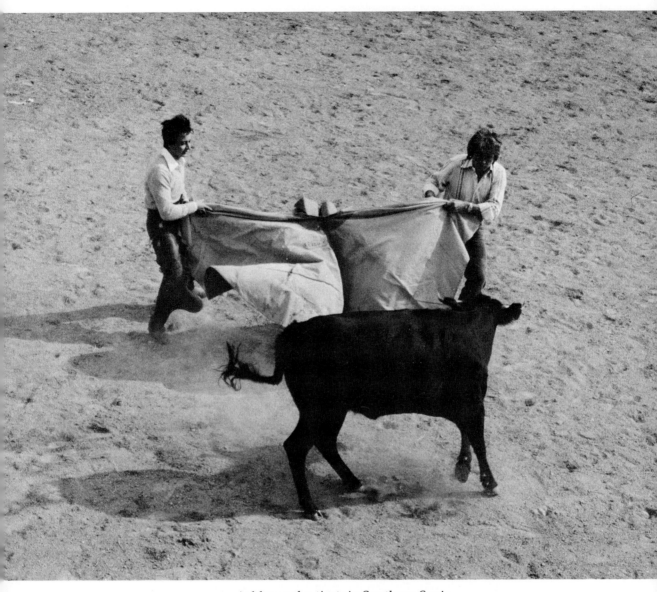

Ashley at the *tienta* in Southern Spain

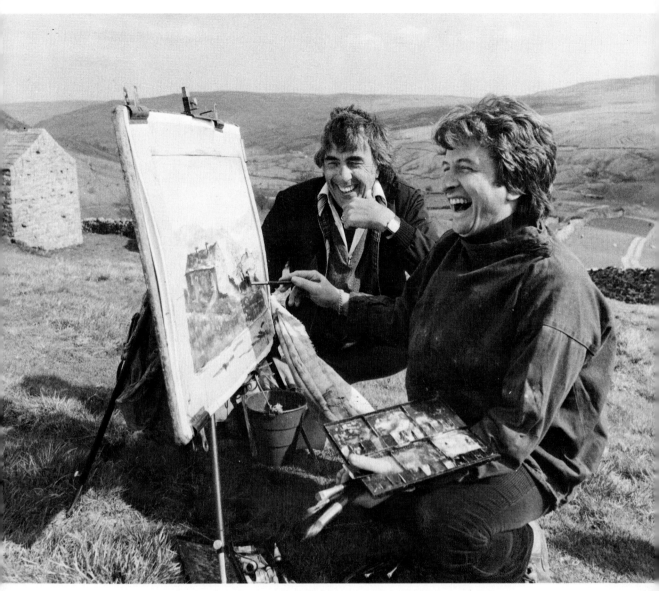

Ashley and Barry Cockcroft, producer of YTV's 'My own Flesh and Blood', on the moors

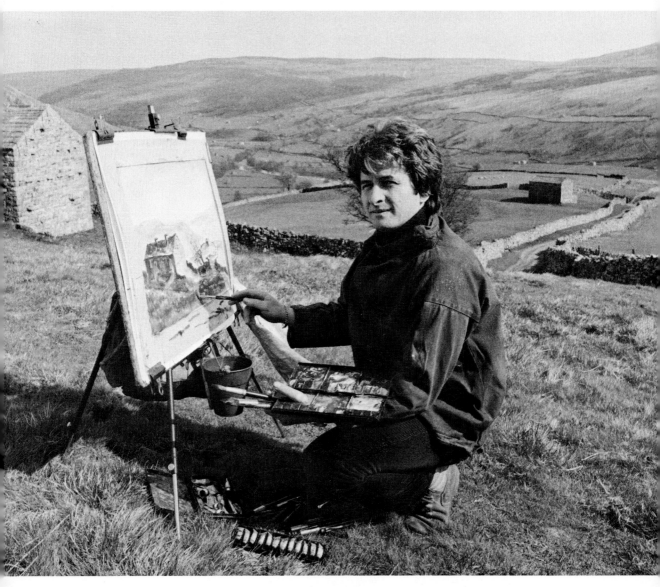

Ashley Jackson

Chapter Nine

As my eighteenth birthday approached, girls were still objects of fantasy to me. I had never seen one unclothed. I still dreamt about that kiss from Patsy in the Limerick hay, and boiled with the erotic thoughts every normal teenage boy has when confronted by the increasingly shapely girls of the same generation. But I had no real girlfriend.

There was, however, to be an incident which completely changed my life in these matters. And it was all over a nude woman. She turned up to model for us at the Fine Art class one evening, and to my amazement took off every stitch. I was goggle-eyed. This new experience proved too much for me. I dissolved into fits of nervous giggles and was dismissed from the class. As punishment, I was ordered to paint the Art School gates.

That humiliation, however, was to turn into a glorious dawn. Through those gates came the cleverer girls from Barnsley Technical School, who had qualified to attend commercial classes in book-keeping, shorthand and typing held in the Art School annexe. One girl sent me into a trance. She was fifteen, petite, fair of hair and her eyes were bright blue. She appeared to float through those gates on a pink cloud.

I made that painting job last three times longer than it should, just so that I could catch another glimpse, perhaps even exchange a word. My burning glances, however, made no impression. But I did find out her name.

Anne Hutchinson.

I tried desperately to think of subtle ways to engineer a meeting but inspiration failed to arrive. I was beginning to think that she would remain for ever a divine, unapproachable object when I had a remarkable stroke of luck. She actually turned up at a reunion dance run by Holyrood School for ex-pupils. It was a Catholic do really, and Anne was not a Catholic. But one of the girls who had attended Holyrood was a close pal and she had been persuaded to come along.

My old dancing partner Dolores was unceremoniously ditched and I homed in on Anne like a missile. She was on my ground – the dance floor. My approach was smoothly confident. And she said 'Yes!' I never left her side all night and she even consented to allow me to walk home with her. I was almost too overcome to speak, and even the prospect of a wrathful Hedley, for the curfew was inevitably shattered, counted for nothing at all.

She was staying that night with her friend and the three of us walked home in the moonlight. We just chatted. I did not even dare hold her hand. It took all my courage to suggest a date. I asked her to come sketching with me the following weekend. She said she would – if her parents agreed.

That week, messages between us were passed through intermediaries at the Art School, since telephones in working-class houses were virtually unknown then. The date, after careful consideration, was granted parental approval. On condition that Anne's eleven-year-old sister, Una, came along too! The three of us took the bus to Stocksbridge and they watched as I sketched away. It was always the three of us in the early days of our relationship.

I still have the painting which grew from that day's work and would never part with it.

Rarely had I been so happy. I had a girl of my own at last. And then – disaster. Shortly after that first date, Anne became very ill with a virus infection. She was in and out of hospital for weeks and therefore vanished from my ken. The courtship seemed doomed because I did not feel that I knew her well enough to approach her parents to find out how she was.

It was my pal, Jim Moran, who urged me to take the chance after

listening to my laments. He volunteered to come with me, so we trailed up to Queen's Drive, Dodworth, a council estate, and I knocked tremulously on the back door. Going to the front door might have appeared impertinent.

The words came out in a rush, tumbling over each other in my anxiety. 'Hello. You don't know me. I'm Norman Jackson. It's about Anne. We've called to find out how she is.'

Her father was very decent. Most guardians of maidenly virtue in Barnsley would have cleared us off very smartly under the circumstances, but we were invited inside. And I had a further stroke of luck. Their television set was faulty and Jim happened to be training as a television engineer. He fixed it. That placed the Hutchinsons in our debt and I was rewarded with a few, closely supervised minutes with Anne as she lay in her sick bed.

I learned later that her father called me 'a cheeky young bugger'.

Craftily, Jim announced that the set would go again if a part was not replaced and offered to come back and complete the job. That meant we had the unassailable excuse to call again.

Thus, the romance survived – and I owe a lot to Jim Moran. Anne and I began to go steady. But her innocence remained intact. It was a case of kisses and cuddles only, with the occasional fumble around the bra straps when things became heated. I did not mind. All I really wanted was to be with her. In fact, I shared a bed with her father long before I ever slept with Anne. I was allowed to accompany them on their annual holiday to Great Yarmouth, which meant I was finally and officially accepted as their daughter's young man. In the North, that's as close as you can get to an engagement until a ring is bought.

We stayed at a boarding-house which charged eleven pounds a week, all in. Mr Hutchinson and I shared a room with a double bed, for it was commonplace in those days for men to do this. No one thought a thing about it then.

Sharing an entire week with Anne was paradise for me. We were content to sit together, as closely as was allowed, on the beach and went walking hand in hand. As it happens, I became a bit of a temporary hero that week when a boy was swept out to sea on a rubber ring by the strong currents near the pier. People were shouting but no

one was doing anything, so I dived in and swam a hundred yards to grab him. I had a bit of a fight against the tide but I had been a powerful swimmer for years and brought him in. A policeman took my name and address as his parents hurried him away, without, incidentally, bothering to thank me!

When I could not see Anne I knocked around with Ron Darwent in the Yorkshire Dales, which continued to expand my artistic aspirations. Sketch book after sketch book filled up and people were beginning to say kind things about my water colours. At home, I still never knew where I stood with Hedley. As I grew older he would sometimes go out of his way to please me, took me along with his pals to see concerts, featuring big names like Count Basie and Lionel Hampton, at the City Hall in Sheffield. And when I desperately wanted to acquire a scooter at the age of nineteen he stood guarantor for the hire purchase agreement. It cost one hundred and twenty-five pounds and it brought a new freedom to life for me and Anne, the ability to go off on our own into the countryside without having to wait for buses.

On the other hand, a wrong word would bring out the violence in the man. By then, Anne was a regular visitor to our house and she was appalled at the way he treated me. But because of her it did not matter so much to me. She was my escape. She was mine. Mine alone. I really did not start to live until I met that girl.

We courted for five years before we could afford to get married. And when we began to plan the wedding, an enormous crisis blew up: over religion. My mother insisted that it should be a Roman Catholic ceremony or she would not attend. Anne's father, an Anglican, swore that he would never walk his daughter down the aisle of a Catholic church. The middle ground of a registry office was rejected by both sides.

As the battle raged, I received an urgent message from Limerick. Grandmother Dolores was seriously ill. Possibly on her death bed. Together, Anne and I had saved fifty pounds to buy essential items for our house but she agreed without hesitation to blow the lot on two air

tickets to Shannon. By then, she knew how important my Spanish grandmother was to me.

When we walked into the hospital ward, grandma shouted out with delight. I was so moved to see her again and so proud to be able to introduce Anne. But so sad to see how ill she looked. Automatically, I began to spill out all my troubles to her – it was almost a reflex action. And when I outlined the details of the dispute over the wedding location, she was very positive.

'Norman', she declared. 'You must get married in whatever church you and Anne want to, and to Hell with all of 'em!'

It was quite a statement from such a staunch Roman Catholic. Later on that day, she politely but firmly dismissed Anne from the bedside saying that she wished to talk to me alone. She became very intense, knowing full well that this would almost certainly be the last time we would meet, which sadly turned out to be true. A distillation of all the advice she had given me during my Irish summers came pouring out. That I must be my own man at all times, that I must keep on painting and have the courage when the time was right to throw everything else up and show the world just how good an artist I was.

'Show them, Norman. Show them!'

Those words have echoed down the years. Whenever despair and rejection came during the next few years – and they were regular visitors – I remembered my grandmother's last exhortation.

I returned to Barnsley determined to face up to both families and insist that it was our privilege to select the place of marriage, and that Anne should have the last word. But the problem solved itself, almost by divine intervention. Apparently, Anne's father had been pondering the situation one day when, quite by chance, he spotted a Roman Catholic priest visiting a house nearby. On impulse, he asked if he could spare the time to come in the house and have a chat. He was called Father May, and my future father-in-law explained things to him. Then he asked what damage it would do to my status in the faith if I married outside the church. Father May was obviously a very persuasive man. Mr Hutchinson was so impressed that he did a complete about turn and announced his willingness to take his daughter down a Catholic aisle.

Although I was very pleased that the issue had resolved itself without more pain, all Anne and I wanted to do was get married. And so it happened, at Holyrood Roman Catholic Church on December 22nd, 1962.

After the expense of the trip to Ireland I was broke. But the bridegroom traditionally had the responsibility of paying for the flowers and taxis. I went through the guest list and worked out that my friends owned enough cars between them to dispense with taxis for the guests. They all obliged.

As for myself, I turned up at my wedding in a fifteen-hundredweight Ford van driven by Ron Darwent. He was my best man. I would guess that not many bridegrooms choose their employer for such an honour. But it underlines just how important he had been to me and I wanted to demonstrate that fact publicly.

The photographer was appalled when we drew up outside the church.

'I can't take a picture of you arriving in a bloody van' he said, despairing. 'You had better come and stand by the church door.'

The reception was held at Anne's house, and the catering was done by her mother. Mr and Mrs Hutchinson had given us a choice: large wedding and small present, or small wedding and large present. Under the circumstances there was no choice. We opted for the large present and they gave us a complete bedroom suite.

The honeymoon was in Blackpool. We scraped up enough money to stay for four days, which meant we could spend Christmas on our own. Away at last from the hassle of families. It was memorable.

We had waited so long, and at last we could sleep together. Three weeks before the wedding, and after five years' courtship, Anne allowed me to make love to her.

It was the very first time for both of us.

Chapter Ten

We came back from honeymoon to take up residence at twenty-seven, New Street, Dodworth, a mining village on the outskirts of Barnsley. It was a two-up two-down terraced house rented out at seventeen shillings a week in a place known locally as 'Top of Dodworth Bottom'. There was no bathroom, we shared an outside toilet with three other houses and the local drains flooded our cellar regularly. But we were proud of that place and happy to live there. With the help of friends, I renovated it from top to bottom.

For me, the relief of escaping the tension of life alongside Hedley was enormous. During the last two years of my courtship with Anne, I often considered finding lodgings. But the expense of such a move could have postponed the wedding for another year. So I put up with the rows and the violence as best I could.

But one New Year's Day he went too far. I had taken Anne out the night before, of course, and he and my mother went out to celebrate, too. They had a fourteen-year-old girl in to baby-sit my small stepsister and I happened to arrive back at the house before them. The following lunchtime I came home for a meal and found my mother in a highly nervous state. She said that Hedley was accusing me of 'getting up to monkey business' with the baby-sitter.

It was ridiculous and totally unfounded. I was twenty years of age, madly in love with Anne and the baby-sitter was a mere child. As my mother finished telling me about the alleged outrage, Hedley walked

into the kitchen. All the years of unhappiness caused by my stepfather seemed to explode in my head. I hurled myself at him and gave him the sort of good hiding he had so often handed out to me.

Indeed, I hammered him. And told him exactly what I thought about him as I went about the job. From that day on he never touched me again. There was an awful lot of silence between us but I felt no pain from that. I suppose I would never have dared to take him on but for Anne, who by then had become the very basis of life for me. She inspired me, then and now, and constantly fuelled my ambition to be an accepted artist.

Anne was directly responsible for what can only be described as the most important painting I have ever done. Immediately we returned from honeymoon, I pulled out the sketch made all those years ago on our very first date. That memorable Saturday, up in the hills near Stocksbridge, chaperoned by her small sister. Clearly, I had been moved by the occasion – moved in a different direction. I had drawn a derelict cottage in the broad sweep of the Ewden Valley and when I finished the painting, using best quality paper, I knew that it was different. Definitely not as bland and pretty as all the others. The mood was darker, more thoughtful, almost sombre. For the very first time I was trying to convey the desolation and echoing emptiness of the moors.

It was the first step along the artistic road I was destined to follow. And I did it to please and impress my new bride, something to hang on our bedroom wall. It is still there. I took it down to the art shop in Church Street, Barnsley, to arrange to have it properly framed. The proprietor, Miss Mary Hayden, knew me well by then and had always been a cheerful and encouraging figure. She had seen many of my paintings over the years and said kind words, but this time her reaction was different.

'My word, Ashley, this is good.'

She took it nearer to the light and examined every corner.

'Ashley, this is quite professional! Very professional, in fact!'

She then did a remarkable thing. The Barnsley Art Society, of which she was a member, was holding a Critics' Night that very week and

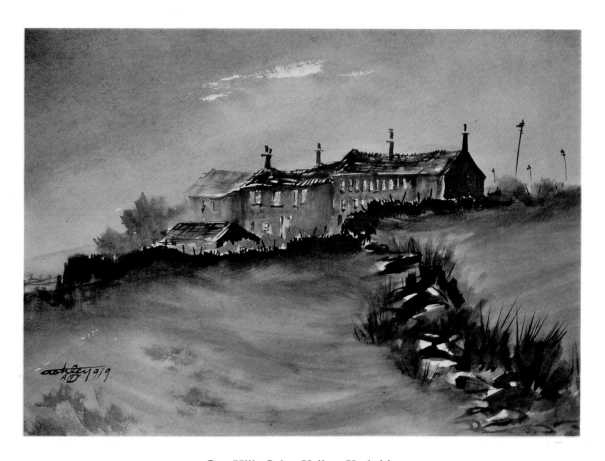

Cop Hill, Colne Valley, Yorkshire

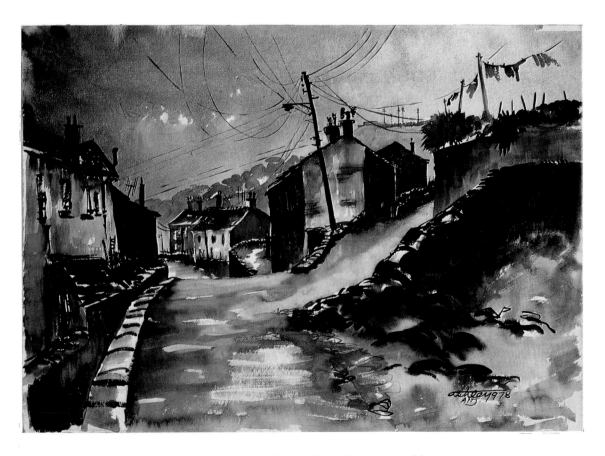

Underbank Old Road, Holmfirth, Yorkshire

three respected authorities had been invited to give their opinions. I was not a member – the Society was a bit too posh for me in those days – but she managed to smuggle that painting on to the wall for the meeting. In all, there were three hundred works on display and the names of the artists had been taped over to render them anonymous.

Each critic had independently to select one painting, assess it and lead a discussion as to its merits and faults. Two of them chose mine. They proceeded to praise it lavishly, and a wonderful evening ended with the name of the artist being revealed. I was made to stand up, which led to some dark looks and some muttering about the fact that I was not a member. But there was a lot of joy in Top of Dodworth Bottom that night when I raced home to tell Anne. I thought I had made it!

Thus encouraged, I began to paint in every spare moment, rifling through the hundreds of sketches done through the years and selecting the best for development. I strove to capture the brooding essence of the Yorkshire Dales. Anne, who had a well-paid job as chief clerk in an insurance office, did not complain once as money badly needed for the house was invested in better art materials and brushes. Naturally, I hoped to recover the cost, perhaps make a profit, by selling my work. Up to then, the most I had ever received for a painting was fifteen shillings.

I also joined the Barnsley Art Society, reverted to the name of Ashley Jackson on the grounds that it sounded more artistic, and gradually built up a large portfolio. By day, of course, I still laboured happily for Ron Darwent.

Around this time I made my first acquaintance with the media. The *Barnsley Chronicle* took an interest and the first stories were printed about the struggling young local lad who specialised in painting the Pennines of Yorkshire.

Innocently, I imagined that all my friends in the Barnsley Art Society would be pleased about the publicity. I was so wrong. It seems that my dramatic advent on to the scene had deeply offended the old guard. Not long after that heady first night with the critics I sent a selection of paintings to an exhibition of members' works. And I turned up at the opening hoping for an enthusiastic reception. They were waiting for

me. A leading member and much respected man of the town marched up and loudly denounced me and my paintings.

He said I was an imposter, not an artist.

'Imposter!' The word rang out round the room, silencing all other conversations. I was dimly aware of several smirking faces. Too stunned to try and fight back, I fled the place and went straight to Anne. And, I confess, I wept bitter tears.

There was more to come. I wrote to a man who had spent years helping and encouraging me, asking for his help to further my career. Harry Glover, the same head of the Art College who had accepted me as a pupil without examination. I wanted the Cooper Gallery, over which he had jurisdiction, to exhibit my work. But he turned me down, and his letter suggested that he considered my paintings to be unworthy of such an honour.

One of the local pillars of the Art Society even went so far as to suggest to the father of another aspiring young artist that his son would prejudice his chances of success if he continued his friendship with me. He was taken at his word, and the lad, who had been a pal of mine since the age of fifteen, began to avoid me.

So the local art establishment closed ranks against me, determined to block any opportunity I had of making progress in the Barnsley area. It came as a hell of a shock to me, and they almost crushed my confidence to pulp. At first I considered resigning my aspirations, sticking to sign-writing as a permanent career and junking my portfolio. One thing I did resign from, and immediately, was the Barnsley Art Society.

But soon the shock turned into a slow rage which burned for years. I recalled what my grandmother had said on her death bed – 'Show 'em, Norman. Show 'em.' I resolved to follow her advice to the letter, and really show the bastards.

The first stage in my campaign was to screw a public apology out of the man who called me an imposter. I could have done nothing if he had confined himself to attacking my paintings, but he had publicly maligned me and my personal reputation. A flurry of letters between lawyers led to a full apology, printed by the *Barnsley Chronicle*. The Press rallied round me from then on and I turned out to be a born

publicist, an invaluable gift. . . But an unforgiveable sin in the eyes of the 'lovers of art' ranged against me.

The next stage was to persuade someone, anyone, to let me stage a one-man exhibition, the only way to get my stuff in front of the public. It was to take two years and a deal of frustration. In the interim, most weekends were spent under canvas in some of the highest and coldest parts of the Yorkshire Dales. Winters as well.

My long suffering wife came with me and uttered not one word of complaint. She waited and watched, shivered and made critical suggestions, cut sandwiches and brewed tea on a primus stove, and kept me warm at nights as the Pennine winds battered at the canvas. Artistically, she drove me on. Any hint of slapdash or lazy work would earn a rebuke. She became my best and sternest critic.

In this way I built up a wide ranging portfolio of water colours and waited impatiently for a chance to show them to the world. And it was Brighouse, not Barnsley, which opened the first door. In January, 1965, I was granted a one-man exhibition. Well, it was really a cheese and wine party held in a private house to raise funds for Brighouse Liberal Party. They asked me for ten per cent of any sales. I would gladly have agreed to ninety so anxious was I to find out if people would actually part with brass for my paintings.

I hung twelve of them round the walls. And waited. Now Yorkshire folk are not too easily impressed and less ready than most to put their hands in their pockets. There was a great deal of critical and silent appraisal as they sipped the wine and munched the cheese.

But they bought six!

The association's officials were so impressed, and cute enough to realise that there could be a handsome profit for them in this art business, that they offered me a full scale exhibition at their headquarters less than three weeks later. I gathered together three dozen water colours, all of Yorkshire, and then designed an enormous poster to hang outside their handsome building in Bethel Street, Brighouse.

'Ashley Jackson Exhibition. Pay Nowt to Come In!'

It was held on a Saturday. They served morning coffee, then afternoon tea and two hundred people turned up. Twelve paintings were sold. One dozen! And another nine people gave me commis-

sions. For the very first time I was paid more than a pound for a painting. One man, Jim Pickles of Halifax, a relative of Wilfred Pickles, actually stumped up for the most expensive on view.

Five pounds!

I used the Brighouse event as a weapon against the art establishment of Barnsley by phoning up every newspaperman I had ever met to protest loudly how a local lad had been obliged to travel thirty miles from home to be given a fighting chance. A good story, they said. And printed it.

From then on there was no going back. I would be a professional artist, even if I had to starve. Anything else would be a denial of life itself.

I busied myself with the commissions, a new experience for me. Mostly I was asked to execute romantic impressions of the client's home or holiday cottage in the Dales. Not always artistically stimulating, but cash in the bank. In those days I would accept anything, apart from portraits. I never did master that side of art. Partly helped by the publicity, interest in my paintings began to spread, further even than the Yorkshire border. I sold steadily, if not spectacularly, and by asking moderate prices managed to move fifty in the following year. Sufficient to spur me to make a vital decision.

To become completely independent.

That meant I must have premises. I could not rely on the whims of local political parties and social clubs to keep my paintings permanently in front of the public. Anne's mother came up with the answer. She found out about a disused barn at the rear of the Thornely Arms in Dodworth which could be rented at one pound a week. I took it, reasoning that I could earn my bread and butter from sign-writing and organise my working week to leave time to build up a studio-cum-gallery, which would be open to the public. But there was one desperately difficult hurdle. To do all this meant a split from Ron Darwent. Freedom was essential.

It took me a long time to summon up the courage to tell him, and I can remember vividly the details of the occasion. We were lettering Barnsley Brewery vehicles in Wakefield Road and I suddenly emerged

from the back of a large wagon to blurt out that I had to leave him. I gave him six months' notice, and promptly burst into tears.

Predictably, Ron received the news calmly and with compassion. He listened gravely as I outlined all my ambitious plans and gave me his blessing. He could have kicked me out there and then and ruined everything but he agreed to all my proposals, even to letting me keep one of the firm's vans if I paid for it out of my wages. He did not even bat an eyelid when I announced that I would have to do some sign-writing to survive, promising faithfully that I would never try to pinch any of his work. And I never did. Even when he was on holiday and his clients approached me with a rush job, I turned them down flat.

Ron will always be one of the finest and truest friends I have ever known. When the six months notice came up, he even turned up at the Thornely Arms to inspect and approve my studio in the barn. It had taken me a lot of time and sweat to convert it. The opening was held in January, 1966, almost a year to the day after that first exhibition in Brighouse.

Another good story, of course. Impecunious young artist throws up job and opens a studio and gallery in Yorkshire mining village. I even made the national newspapers with that one. The natural consequence of this was public interest and a gratifying number turned up to watch me paint and occasionally buy the things. I began to wonder if I could ask as much as ten pounds for the better paintings. I also sold rural craftwork, supplied by fellow members of the Guild of Yorkshire Craftsmen who had admitted me as their youngest associate largely because I had graduated to glass gilding under the tuition of Ron Darwent. Some days I had to slog for sixteen hours to cope with the sign-writing and looking after the studio.

Two months after the studio opened, the curator of Newark Art Gallery was impressed enough by my work to offer me a one-man exhibition. A real one this time. Not a one day affair, but two whole weeks. I drove down in Ron's old van to Nottinghamshire with thirty paintings. Seven of them I had already sold but I managed to borrow them back so they could be displayed as 'Not for sale – on loan from private collections'. Very posh!

That left twenty-four for sale. They were all my impressions of the Yorkshire Dales, worked from deep-frozen sketching sessions along the rain-swept Buttertubs Pass across which Wesley had once ridden a horse to spread the Methodist word to Swaledale, up in the misty heights of Wensleydale and Arkengarthdale, and even higher to Tan Hill. Prices ranged from three guineas, (guineas, mark you – I had definitely gone up-market), to fifteen guineas for a study of Tan Hill pub, the highest hostelry in England.

They sold the lot. Every last one.

By now, my supporters began to outnumber my detractors. One enthusiastic member of the first group was Stanley Chapman, a tall, spindly and perpetually smiling man who came to my first exhibitions in Brighouse and remained a good friend from then on. An artist of much talent himself, he urged me to try and become a Fellow of the Royal Society of Arts. With his support, I made it at the age of twenty-six.

I knew by then that to make substantial progress I would have to establish a foothold in the capital city, and being able to put FRSA behind my name was a good start. In 1966, I made a bid for the top. I drove down to the Royal Academy and submitted three paintings to be considered for hanging at their annual exhibition. They were promptly thrown out. So I came up with another news-worthy idea. If the Royal Academy would not have me, I would stage my own exhibition in London. . . Alongside the pavement artists on the embankment.

I set off one Saturday in the van with a load of paintings and two pals, Jack Brown and Peter Midwood, who came along for the fun. I made sure that the media knew all about it well in advance and the BBC promised to send a film unit to the scene. We arrived in the evening and decided to have a close look at London's night life, the hub of the Swinging Sixties. Peter had brought his guitar so we busked round the pubs of Chelsea for beer money. It was quite a session, and we slept it off in the van parked in a back-yard in Tottenham.

England won the World Cup that weekend, and really did me a favour. When we dragged ourselves round to Westminster Bridge in the morning the streets were full of celebratory people, ready for anything. The paintings were propped up against the wall and drew a

large crowd, much to the annoyance of a pavement artist close by. He complained bitterly to the police about 'a vagabond student' trying to pinch all his business. So up came the law, notebook in hand.

But he was friendly, even when I had to admit that I did not even know a permit was required for this sort of thing. He allowed me to stay, providing I did not attempt to sell the paintings. As it happens, I did manage to shift a couple on the quiet though the money did not cover my expenses. But that mattered not at all, for along came the BBC camera team. An enormous crowd gathered. They even had to rope the area off with the help of the police so that I could be interviewed.

Public exposure on national television. That almost broke the collective heart of the Barnsley Art Society, and it takes a big clout to split millstone grit.

Chapter Eleven

Everything happened in 1969.

For more than eighteen months before that magic year, my career had been moving sweetly – if you read the newspapers. 'Another Exhibition for Ashley Jackson. . !' 'Barnsley Artist Boosts Export Market. . !' 'the Royal Institute Accepts Ashley Jackson painting. . !' There were many more headlines of a similar nature.

But headlines do not pay bills. The real story was about financial hardship. Believing that success breeds success, I developed an expensive public façade. Local artist makes good. To bolster the image I acquired an MGB GT so that I could surge up to art galleries in style and, when Anne became pregnant with our first child in 1968, went to look for another house. We had lived in our terraced cottage for six years but I realised it was no place to rear a baby. The cellar became a very unsavoury place after every spell of heavy rain. I found a modern, semi-detached bungalow close by and raised the necessary mortgage.

Eventually, Anne had to quit work and her life-saving wage of eighteen pounds a week went. So did the MGB GT. There was a big boost to our morale when the Royal Institute of Painters in Water Colour accepted one of my submissions. It was bought for more than fifty pounds by Dewsbury Corporation, principally because it was an industrial scene from that sturdy woollen town and they were keen on building up a collection of locally inspired art for the town gallery. But the occasional grand fee did not meet the expense of promoting myself, driving regularly to London on selling missions, drinking with the Pressmen and paying for the finest materials and frames.

Truth was, had I not slaved away quietly, until midnight some nights, lettering vans, gable ends, lavatory doors, anything people would pay money for, we would have sunk without trace.

And one day in the summer of 1968, I piled even more pressure on to our delicately balanced financial position. I called in to see my friend Miss Mary Hayden, to buy materials at her art shop in Church Street, Barnsley, and she told me excitedly that the small florist's shop next door to her premises was closing down. Would it not be a splendid idea to open a gallery slap in the middle of town and right next door to an art shop? It was an irresistible proposition. I went straight round to the estate agent and agreed terms. Five pounds a week rent. I rang Anne, now large with child and in charge of the studio-cum-gallery in Dodworth since she had stopped work.

She was aghast. Five pounds a week! How would we be able to pay that and the mortgage. Just where was the money coming from. But it was too late – I had already signed up. Using the last of our meagre savings, we opened with a flourish on the last day of August, 1968, the first professional art gallery ever in the dour mining town of Barnsley. It was good for another batch of stories in the local and regional newspapers.

If only I could have swapped headlines for rich clients.

Anne's mother was drafted in to help with the new enterprise as I redoubled my efforts to kick down the gates of London and raise the money to finance it. Every week without fail I drove down the motorway and pounded round the art galleries. To save money, I slept in the back of the van in Hyde Park and then changed out of my jeans into a suit in a vain attempt to impress the art mandarins of the capital.

To a man, they showed me the door. Sometimes kicked me out, in the verbal sense. One metropolitan gallery was so impressed by all the publicity about me that they actually sought me out and invited me down to show my portfolio. Thinking I had broken through at last, I raced down and swept into the place exultantly. And froze. Someone at the gallery had obviously made an error. It was devoted almost exclusively to surrealism, and the walls were covered with the weirdest works of art I had ever clapped my eyes on. The proprietor was a woman who took one glance at what I had to offer and launched into a

tirade of hate about chocolate-box painters which would have made her an honorary life member of the Barnsley Art Society, had they heard it.

That was the lowest point of a very bad period. I grabbed my paintings and ran all the way to a phone box, rang Anne and told her I was finished. She would have none of it, and for the hundreth time during those desperate times firmly but lovingly nursed my confidence back into shape. Urged me to battle on.

So I did. The year stayed as lean as a coalminer's whippet but together we sold enough to survive.

On Monday, November 11th at 6.00 am, Heather Jackson weighed in at six pounds and four ounces. And as the New Year dawned to the accompaniment of the fully stretched lungs of our infant daughter, everything began to change. The Year of Our Lord, one thousand nine hundred and sixty nine, will shine like a beacon for ever.

It all began in Dewsbury, which then had a wildly generous attitude to local artists when compared to the Burghers of Barnsley. They admired my stuff unreservedly – indeed, these days have a large collection – and arranged an exhibition for me. Now exhibitions are always a trial for an artist. You stand there on show, trying not to smile fatuously, trying to remember the names of the dignitaries, answering lots of questions whilst trying to strain the hearing to catch what people looking at the paintings are saying and all the time praying to God that someone will pull out a chequebook. The first sale is always vital because it generally triggers a domino effect. But on that occasion in Dewsbury all thoughts of material gain were chased from my mind when a grey haired old man wandered into the room and began inspecting my paintings very closely. I knew who he was.

James L. Brook, one of the art world's elder statesmen. An artist himself, he lived in Huddersfield, was an acknowledged expert and critic and a restorer of rare old works. When James L. Brook spoke, everyone listened. And he had another, even more fascinating attribute.

He was the closest friend of the great master, the legendary L. S. Lowry.

I was briefly introduced to him and my hands began to sweat. He did not say much. But a few days later I received a letter from him. It was amazing. He wrote that never before had he met such a young water colourist capable of painting in such broad, confident washes. He had tried for years without success to perfect the same technique. He urged me to go on painting like that, to the exclusion of all else.

His words galvanised me. Never before had such an authority praised my work. Next month I drove down to London with a light heart and a soaring confidence. Now I knew I had talent. It had been officially confirmed. So I must succeed. To begin with, London inexplicably failed to agree with this assessment. Yet it did not depress me as in days gone by, for the opinion of James L. Brook proclaimed that they were wrong. I acquired a list of every art gallery in Central London and began to knock on the door of each one in turn.

In the early summer of sixty-nine I walked into the lush, West End premises of the Upper Grosvenor Gallery. At the time, they were taking down an Annigoni and hanging a Dame Laura Knight. On the next floor a Royal couturier plied his trade. An exquisitely elegant young man, dressed in a green velvet suit and called Rodney, waltzed over to inquire the reason for my presence. A month before I would probably have turned tail, but without ado I went into my sales pitch. Inferred that I was presenting the Upper Grosvenor Gallery with an opportunity they would be foolish to ignore and indicated that I would grant them the privilege of exhibiting my work. Rodney looked at me for a long moment without saying a word. Lord knows what he thought about this unlikely lad with the broad Barnsley accent but he did start to flick through the portfolio being thrust in his direction.

'Leave them with me,' he said. 'I will show them to the governors. Pop down next Monday and I will give you their decision.'

I popped down next Monday.

'So sorry,' said Rodney, with a light laugh. 'I'm afraid the governors have been at Wimbledon all week and did not have the chance to see your portfolio.'

That irritated me. Convinced that I was being messed about by a fancy Southern gentleman, I pointed out in my rough Northern way that 'popping down' to London cost a lot of money and if he thought I

was going to dance a jig on the whim of his bosses he was sadly mistaken.

'If you do not consider my paintings worthy of an exhibition in your gallery, why not come right out and say so!'

The ploy worked. Rodney was most contrite, begged me not to take my portfolio away and promised to expedite matters. At the time I was hardly convinced and trailed back to Barnsley with a heavy heart.

Three days later a telegram arrived. The governors offered me a one-man exhibition, from August 13th to August 30th. Almost three weeks, and in the heart of London.

When the elation subsided, I went round all the paintings I planned to show and marked them up. There was a one-third commission to pay, so fifty guinea works went up to one hundred and twenty and so on. When I stood back and pondered the new prices I must confess I quailed a little. Perhaps I had gone too far.

The day came to turn up at the gallery with my collection and meet the governors face to face. It was a daunting experience because the moving spirit among them was the Duchess of St Albans. Before leaving Barnsley I had asked my more learned and better connected friends just how the heck I should address a Duchess and listened to a motley variety of suggestions.

The Duchess turned out to be French born and the most devastatingly elegant lady I had ever seen in my life. She was attended by a chauffeur and came floating across to me as I supervised the unpacking of my portfolio, dressed superbly. And held out one hand.

The experience unnerved me. I heard myself apologising, saying that I did not know the correct way to address a Duchess. Was it 'Your Grace' or simply 'Ma'am'? She laughed out loud, and I went red with embarrassment.

'Ashley,' she said. 'I don't go for all that formal stuff. Call me Suzanne!'

Quite a moment for a back-street lad. So Ashley and Suzanne it was. She turned to the paintings being hung round the walls and inspected them keenly. After a while she began to frown and mutter something. Then spoke out clearly.

'No! That will not do. That will not do at all!'

Seized by panic, I wondered if I had gone too far with the pricing. But it was exactly the opposite.

'Put 'em up,' commanded the Duchess.

Attendants scurried to remove the price tags. And for the first time, the unprecedented sum of one hundred and fifty guineas was asked for an Ashley Jackson water colour.

I had brought thirty of them to display and ten of them were sold. It was almost unheard of for a completely unknown artist to shift so many at a first London exhibition. It was just as well. Anything less and our bungalow would have been on sale, too, with the Jackson family moving back into a rented cottage. To pay for the expenses, such as the best frames and a reasonable hotel (I felt I could not sleep in the back of the van on this occasion), I had been forced to go cap in hand to the bank manager.

Naturally, I took care to inform the Press all about the exhibition. So the name of Ashley Jackson was paraded through the national news-papers, from William Hickey to the *Times*. And I made the front page of the *Barnsley Chronicle*.

The critics came too, and they were kind!

'Ashley Jackson has made the moors his own. . .' 'The Brontë atmosphere comes through strongly. . .' 'he uses his water colours boldly, with broad washes by a full brush. . .' 'this is an artist who is a realist'.

It was abundantly clear to me by then that the number of paintings I sold was directly related to the number of column inches in the public prints so I determined to keep my name there as often as possible. I even persuaded the owners of an Icelandic trawler to let me make a voyage with them, partly because I knew it had media value but also because I came to see the Yorkshire moors as frozen seas and wanted to increase my knowledge and perspective of this essential ingredient in my paintings. So I clambered aboard the seventy foot ship *Conjuan* and we sailed straight into a hurricane. At least, that was what it seemed like to me. The seas were so mountainous and the winds so powerful that we had to flee back to the safety of port after a mere two days.

But I got what I wanted from the trip. Several wobbly sketches, executed painfully in between bouts of retching over the side, were turned into profitable paintings.

That was the beginning of a lengthy courtship between me and the sea which continues to this day. Later on, largely because of a friendship struck up with Roy Mason, Member for Barnsley who became Secretary of State for Defence, I was commissioned to paint various ships of Her Majesty's Navy. I specifically asked to portray ships in winter seas to further develop my appreciation of the vast swell of the Pennines. So they arranged to send me to Scapa Flow in November.

I duly reported to *HMS Hermione* at her berth in Liverpool where I was royally received by the captain and given the admiral's quarters. The Navy has always been outstandingly hospitable to me. After a few drinks, some of the officers asked me if I was in the mood for a bit of fun ashore since it would be the last chance for a couple of weeks. I thought it would have been churlish to decline, so five of us went carousing through some of the seedier parts of that remarkable port. We ended up in a sauna and massage parlour which, to my genuine surprise, seemed to be staffed entirely by nubile young girls. I had never even seen a place like that before but tried to act nonchalantly. We all sat stark naked in the sauna and from time to time left to dive into a pool filled with ice-cold water.

For some reason, I found myself all alone in the water. And as I clambered out, frozen from stem to stern, one of the young ladies danced up and dragged me off to a cubicle. I attempted to cover myself with a towel, since exposure to cold water has a decidedly negative effect on one's masculinity, but she expertly snatched it away and ordered me to lie on a table. I dived on, belly down, but she insisted I lie on my back. As I did so, I caught sight of four hysterically amused faces peering at me over the curtain of the cubicle. A chorus of friendly abuse about certain anatomical deficiences followed.

It was a set-up.

But I enjoyed the voyage and I was well pleased with the artistic results. A month or two later I was informed that there was to be an official presentation, to the captain, of the painting I had finished of

HMS Hermione. They expected me to attend. I agreed, but instead of proceeding to Liverpool or Portsmouth as I expected, I was whisked off by RAF jet to Gibraltar where *Hermione* was with the NATO fleet on exercise. Admiral Sir Terence Lewin, Commander-in-Chief of the Fleet and later First Sea Lord, flew in to make the presentation. He did it to the accompaniment of pipes and bugles on the quarter deck of the ship.

It was followed by a nerve-racking lunch. Just me and five admirals. They all asked me to call them by their first names but I just could not bring myself to do it. I told them that they must put up with being addressed as 'sir'.

Half way through the meal, Admiral Sir Terence raised his glass, turned to me and said: 'Here's to you, Ashley.'

'Thank you, sir,' said I, wide-eyed.

'Ashley Jackson,' continued the Admiral, 'I have to say that you are a true mariner.'

'Thank you, sir!'

'Well, perhaps more of a sub-mariner.'

'Sub-mariner? What do you mean, sir?'

I could feel the rest of the table trying to suppress amusement.

'Well, Ashley. Let's put it this way. Did you enjoy your run ashore in Liverpool?'

At this, the entire table dissolved into laughter. It seems that the entire fleet had been regaled with the story of that visit to the sauna and massage parlour.

Chapter Twelve

There were many good days and several glorious moments in the summer of sixty-nine, that year of grace when the worry and the doubt began to recede. But the most glorious moment of all, one of the greatest of my life, occurred on October the eleventh at ten o'clock in the morning precisely.

A few moments before, I had been trying to buy a bag of crisps in the corner shop near to my gallery, which had then been extended by knocking through the wall to Miss Hayden's art shop. I had prospered sufficiently to acquire her business, and she stayed on as an employee.

It had been a quiet day with not a customer on the horizon and I had missed breakfast. Just as I was about to be served with the crisps Miss Hayden's young assistant ran into the corner shop to tell me that two gentlemen had come into the gallery and they looked important. I told her they must wait because I was hungry, and eventually strolled back, dressed in jeans and cowboy boots, with my mouth stuffed full of crisps. Miss Hayden was gazing at one of the visitors as though he had just stepped from a spaceship. I followed her fixed gaze – and instantly knew why.

He was old, gaunt and wore a long black coat, peppered with dandruff, and sported a starched white handkerchief from the top pocket. He had a hat to match, a winged collar and a tightly tied black tie.

It was L. S. Lowry.

I froze, too, and the crisps turned soggy in my mouth. The spell was

eventually broken by his companion, an old friend called Colonel Knowles who kindly chauffeured Lowry in his car whenever he wanted to make a long journey. He introduced himself, and then turned to the great man.

'This is Mr Lowry,' he said.

'Yes, I know.' The words came out slowly. 'I feel as though Jesus Christ has just walked through the door!'

The figure in black turned deliberately to look at me.

'Nay, lad. Nay! I'm only human.'

Not to me, he wasn't. Not at all. He was my leader, the North's supreme artist of the century. And there he was – in my gallery! He had come looking for me. Ashley Jackson, the fledgling. Motored all the way over the Pennines from his home in Mottram, Lancashire, to seek me out. James L. Brook was at the root of it. He had told Lowry about that exhibition of mine he had attended, and on one of the old man's visits to Huddersfield had taken him to see the tail end of another exhibition. Featuring my works at the George Hotel. Apparently, Lowry had examined them and then asked the head waiter where he could find me.

'Do you hear, sir! Only human!'

L. S. Lowry called everyone 'sir' and the word jerked me out of my dazed condition. Miss Hayden also recovered sufficiently to hurriedly bring him her own, personal Windsor chair to sit on, an offer which he accepted with old-fashioned courtesy. He then began to gaze keenly around. We watched in silence, wondering what to say next. He spotted the display of art materials and exclaimed: 'Oh, good. I see you sell sketch books. I will buy one.'

I offered to give him one but he refused, saying that I could not afford to do things like that. It was nervously wrapped for him by Miss Hayden as he proceeded to inspect my paintings displayed around the walls. For me, it was like waiting for a High Court judge to pass sentence. But there eventually came some blissful words, delivered in a rapid style to which I was later to become accustomed.

'I take my hat off to you, sir,' proclaimed L. S. Lowry. 'Indeed, I will take it off to any good water colourist, and you are one of the finest there is, sir!

'I only paint in oils, and that's easy compared with what you do. Mind, if you want some advice from me, I would tell you to give it up. No one should paint for a living. It's too painful. But if you intend to carry on, then keep doing the same thing. It is very good, indeed, sir!'

As I paused to digest his words, he turned to his companion and announced that he was going to purchase 'one of this young man's paintings.' He chose a dark-hued impression titled 'Where Counties Meet', which I had done at a point on the moors where Yorkshire, Lancashire and Derbyshire nudge against each other.

I tried, once again, to make it a gift. At that particular moment I would have given him a dozen. But he would have none of it. So I charged him ten guineas. We chatted on and I told him about that first success in London at the Upper Grosvenor Gallery a few weeks before, and the bitter struggle it had taken to gain a toehold in the capital.

'It was just the same for me, sir,' he said. 'Keep fighting, Ashley. Keep fighting if you mean to stick it. They do not care for the likes of us down there. They used to laugh at my paintings, too.'

'But they are not laughing now, are they sir!'

Before he departed, he called for pen and paper and wrote down his address and telephone number, saying that I could call to see him any time if I wanted advice.

For me, the rest of the day went by in an out-of-focus mist. Miss Hayden, too, was not capable of coping with the every day details of life and Anne had to be called in to take over the running of the gallery and shop. What a man and what a moment! I do not think I will ever fully recover from that experience.

Two weeks later, I took him at his word, travelled in fear and trembling to Mottram and knocked on his door. It reminded me strongly of Wakefield Prison, where I had started teaching inmates about art, because that door must have had six locks, and a chain. L. S. Lowry obviously wanted to keep the world at bay.

The door creaked open and the old man peered out.

'Yes,' he snapped. 'Who is it!'

I swallowed hard but my voice nearly dried up.

'It's Ashley Jackson, Mr Lowry!'

There was a long silence, and I thought that perhaps I had presumed

too much, but the door was eventually flung open and he gave me a warm welcome. In the private war he waged, I had been granted the status of ally. Thank God!

He led me through a dimly lit, bare-plastered corridor into a sitting room which had not changed since his mother died in 1930. His lifestyle was simple – threadbare even. Three well-worn chairs were drawn up to a gas fire and numerous clocks ticked round the room. Paintings were stacked in piles against the walls, some of them very valuable, and beside him on a table was a large bowl full of letters. They were all unopened.

We talked for hours.

For the next six years I saw L. S. Lowry twice a month, on average. He became my guru, and I revered him. Then and now.

Sometimes I would be called to the George Hotel in Huddersfield where he regularly met James L. Brook for afternoon tea, but mostly I travelled to his home. Latterly, he encouraged me to take my daughters along – by then I had two, for on September 15th, 1970, Claudia arrived – because he was able to relate to children better than adults and never talked down to them. In fact, he would often talk to me through Heather and Claudia, telling them what he thought their father should do. They loved every moment in his presence and listened wide-eyed. L. S. Lowry had a special kind of aura, which I was later to notice that other truly eminent men projected, which made every visit memorable. He listened patiently to my problems, which were so similar to his in the beginning, and poured out advice. Much of it was practical. How to cope with critics, agents and gallery proprietors without losing either my self respect or my shirt.

'Ashley,' he said. 'If anyone is going to make money out of your talent, let it be you!'

The distillation of a lifetime's experience in the art world was freely given to me. To the meetings with James L. Brook in Huddersfield I would take my most recent paintings to ask for guidance about which I should offer to various exhibitions. I asked him to criticise them, but Lowry refused.

'Each one is trying to say something and that must be respected,' he said. 'So why should I criticise any artist's work.'

But he had amazing judgement, nevertheless, when I was agonising over which I should offer to the important annual exhibitions once, when flicking through a portfolio of new stuff, I realised that I had inadvertently included one which I considered to be of poor quality. So I managed to press it against another and succeeded in turning over two at once. But he was not deceived, and demanded to see it.

'Why did you not want to show it to me, Ashley?'

I explained why.

'But it is the best of the lot. Send it to the Royal Institute's next exhibition.'

I did, and they accepted it!

He told me many stories. Often they reflected his love of children, which was so evident when I took my own along on those visits to Mottram. Such as the time he was painting a cricket match and a nine-year-old girl who lived near him turned up to watch. At the time, he was painting in a clump of trees behind the pavilion when she exclaimed:

'Mr Lowry! What are you doing. You know you can't paint trees.'

'Oh,' said Lowry. What should I do then?'

'Put some mill chimneys there instead, of course!'

'She was right, absolutely right,' Lowry told me. 'I did just that, and it worked a treat.'

On another occasion he was agonising about how to tackle the painting of a bridge on one of his visits to his beloved North East.

'Do you know,' he said. 'I spent half the day walking round that bridge trying to find the best angle and got nowhere.

'So I went for a walk in the centre of Newcastle and came across an exhibition of paintings by children. And there was a painting of that bridge.

'It had everything in it that I was seeking to capture. It was so good that I gave up the idea of doing it myself.

'The artist was a girl, and she was six years old!'

Although he was so kind to me and so gentle to my kids, he was basically an embittered man who considered that society treated him

and most artists, rather badly. He would repeat variations of the gloomy words I heard on the very first occasion we met.

'You should never have become a painter, Ashley. It involves too much pain. It is not worth it.'

We exchanged tales of disillusionment and humiliation. I suppose every artist can display his own catalogue of rejection, particularly those from the northern counties. Success usually extinguishes the anger this creates, but in Lowry it burned until the end of his days.

'When I started, they scorned me,' he said. 'Now they want to give me honours. Well, they can keep them, sir. They can keep them!'

The real significance of this last remark was to be brought home to me later, through another friend I made in the vintage year of 1969. The Right Honourable Roy Mason was President of the Board of Trade when I first met him, but progressed to very high office. He had started as a boy of fourteen sweating deep in the bowels of the earth at the coal face of the Wharncliff Woodmoor number four and five pits, and clawed his way out into the sunlight to become Member for Barnsley on a virtually permanent basis. He went on to join the top echelon of the Labour party.

Roy had always been intrigued by my relationship with Lowry, who was considered to be a recluse by most people. He declared that he would be fascinated to meet him and could I arrange it. At the time he was a very grand figure, the Secretary of State for Defence, no less. So I did arrange it, and I suppose it was a measure of Lowry's regard for me that he was charm itself when I presented Roy Mason and his wife one evening on that bleak doorstep in Mottram. I was lucky. When he was in the right mood, Lowry loved to hold court and I was quite amazed to see that the Right Honourable Roy, a man used to command, was clearly as thrilled as a small boy brought face to face with his hero.

He even listened with glowing respect as Lowry embarked on a comprehensive attack on the administration of which he was a leading member.

'I am afraid, sir, that your government does nothing to help artists like myself and our young friend here,' said Lowry. 'Do you know that I am allowed to keep eleven pounds out of every hundred I earn! And

you give us no protection at all against unscrupulous agents and galleries. In France, it is different. They appreciate their artists in that country. They have legislation to protect them.'

I knew only too well what he meant. In this country, we are at the mercy of every predator. Galleries invariably work on a sale or return basis, thus eliminating the major financial risk, and charge exceedingly high commission rates. That is not allowed on the Continent. Here, artists never get a share of the financial benefits when their works escalate dramatically in later years, something Lowry in particular resented for obvious reasons. In France, and elsewhere in the EEC, he would have received a royalty on re-sale.

We chatted on for three hours, sitting in the semi-darkness around the hissing gas fire, but a disturbing element surfaced in the conversation. I had noticed for more than a year that the master's general distaste for the world outside his shuttered home was approaching the point of total despair. It had been a slow process. As long ago as 1970 he told me that one morning he had risen from his bed and, on the spur of the moment, decided to quit painting for ever. He went downstairs, threw away all his brushes and paints and never went back on the decision.

'What's the use?'

That was the phrase he used over and over again when he talked to me.

When the political banter ended during Roy Mason's visit, the talk ranged around pleasanter subjects and Lowry mentioned that he was planning to visit Sunderland.

At this, Roy, who was enjoying himself enormously, leaned across to me and whispered: 'He's going to see a bird!' But the old man was razor sharp and he spotted the aside.

'What is that you say, sir!'

It was as though a headmaster had caught a boy talking in class. Roy blushed, put on his best Parliamentary voice and said that perhaps he was intending to visit a lady friend. Lowry grimaced.

'No, sir. I have never had a young lady, and never has a young lady wanted me!'

There was so much sadness in the man. And in the twilight of his

110

years it became an affliction that ached more and more. He would lament to me that life was over for him. On one visit he was especially low.

'Ashley, all my old friends have gone. I went down to the village today and they are flying the flag at half-mast over the Workingmens Club for the last of them.

'I am ready to go, too.'

A couple of weeks after meeting Lowry, Roy Mason announced that he was taking me to number ten Downing Street. A reward, I suspect, for the introduction. An official car with flag flying from the bonnet came to pick Anne and myself up at the hotel and we made a dignified progress down Whitehall. A mounted sentry saluted us with his sword along the way. We were ushered straight into Number Ten and I was astonished to see Harold Wilson bounding down the stairs to greet us.

'Hello Ashley,' said the Prime Minister. 'We met before, if you remember.'

We all went upstairs to his private apartments where Roy Mason was already installed. Once inside, Mr Wilson pointed to an original Lowry, on loan from a private collection, hanging on the wall.

'I believe you know the gentleman who painted that,' he said.

'Yes, sir. Very well indeed.'

'A strange man, Ashley. Do you know he was offered a knighthood and turned it down. And he also refused to become a Companion of Honour.'

I was not at all surprised.

L. S. Lowry was a man of principle. And when he closed the door on the world, there was no way of prising it open. I felt very privileged to be granted a regular place at his side during the last years of his life. His public appearances during this time were very rare, and always attended by an anxious, if wary, bevy of Pressmen. His austere manner on those occasions gave pause to the boldest reporter but he had a mischievous side to his character and, in the right mood, he loved to poke a little gentle fun at the Press. On one occasion he turned up at the opening of a retrospective exhibition of his work, which predictably caused a stampede of cameras and notebooks.

111

'Mr Lowry,' said one bold spirit. 'Which do you consider to be the best painting on display here?'

Lowry looked at him coldly, then turned and tapped with his walking stick a hanging glass box containing a fire extinguisher.

'That one, sir!'

But Lowry, after a little more pressure, relented and indicated a very small canvas half hidden among his larger and better known works. Thus encouraged, the questioning continued.

'Mr Lowry, how much did you sell it for?'

'Fifteen guineas, sir.'

'And how much is it worth now, Mr Lowry?'

'Oh, I don't know. Fifteen or twenty thousand pounds, I suppose.'

'And how do you feel about that, Mr Lowry?' chorused the eager reporters, sensing the possibility for a good quote about the inequalities of the system.

'Like a racehorse which has won his race,' was the reply.

But in 1974 the old horse had done with racing. He said to me again that he was ready to go. The last time I saw him he talked about a large-scale retrospective exhibition of his work which the Royal Academy was mounting with full pomp and circumstance. I told him I would love to go.

'Then you shall, sir,' he said.

Not long afterwards, I received a telephone call from another of his small circle of regular visitors. He said that Lowry was in hospital with pneumonia. I rang the matron to check his condition and find out when I could visit him.

She was clearly upset. There would be no visits.

'Mr Lowry does not want to get better,' she said. 'He has lost the will to live.'

And so, in February, 1974, L. S. Lowry willingly departed this world. I heard the news on the car radio as I drove over the moors. Not since my Spanish grandmother died had I felt such a deep sense of personal loss.

A few weeks later, an engraved invitation to the official preview of his Royal Academy exhibition dropped through the letter box. And it

was with a special sense of pride that I marched into that hallowed place. At the time, a brass band was playing in the courtyard, which would have pleased Lowry. But the event teemed with the pompous, rich, well-connected and talentless people who hover shrilly around the periphery of the art world. One of them approached me, grinning superciliously.

'Ashley Jackson! Surprised to see you here. How on earth did you get in!'

I spat out the reply.

'Not the way you got in, mate. I'm not like you. I am here because the master himself invited me, *personally*!'

Chapter Thirteen

The various beneficial events of 1969 enriched my life dramatically, but not in the financial sense. True, I moved positively away from the verge of bankruptcy, where I had been teetering uncomfortably for so long, but my expenses soared as I moved into a new and potentially rewarding area. The world of television.

I still did not have enough left, after overheads, from the sale of my paintings and the profit from selling art materials to give up sign-writing. It provided the bread and butter. In fact, when I heard the news of Lowry's death I was driving to do some lettering for a plumber. And before I could complete the job and collect the money, his phone was ringing. It was Austin Mitchell, Yorkshire Television's top screen personality of the time and now MP for Grimsby, who had tracked me down. Could I come into the studio immediately to be interviewed about L. S. Lowry?

Of course I could. Television was the ultimate in promotion.

For five years before that I had been a regular visitor to the studios and the bars patronised by the YTV men. I had no expense account like my new friends, but they became real friends. I admit that at first I went in to exploit the new major independent television station when it opened in Leeds. But I stayed to find kindred souls. They respected me as I respected them. Austin was one, of course, and I spent many hours eating curries and Chinese *tim sum*, plotting programmes with producers like Sid Waddell, now a household name because of his darts commentaries, Graham Ironside and Barry Cockcroft, who won

114

critical acclaim and awards all around the world for his documentaries. To this day, they are counted among my closest friends.

Television provided a new dimension in the eternal quest for public attention, and the newspaper headlines were complemented by minutes of screen time.

It all led to a resident spot on 'Pebble Mill at One' when the BBC afternoon show opened up in Birmingham and immediately won a large audience. That meant national television exposure week in, week out, and nothing can match that to push someone in my line of business. But even with the fees from the BBC, the ever mounting costs of staging exhibitions forced me to accept sign-writing jobs. On several occasions, puzzled passers by would stare up at me as I worked on shop fronts and call out:

'Hey, lad. I've just seen thee on Pebble Mill at One. What the 'ell are you doing up that ladder!'

They all assumed I had it made.

Incidentally, I was still having terrible problems with spelling. I do believe I suffer from a form of word blindness. On one occasion I was painting the words 'British Legion' on a gable end and missed an 'i' out of British. Putting it right was a problem because the letters were seven feet high! And there was an enormously embarrassing episode when I did the gold lettering on the window of a chartered accountant and missed out the 'o' in accountant. It took them days to spot it, and it became the butt of much ribald comment from passers-by.

In contrast, when I was not perched precariously on a nine inch plank high above the pavements of Barnsley I moved in some rather exalted circles. There are probably more millionaires to the square mile in Yorkshire than anywhere except Texas and a few of them took a shine to my paintings. Occasionally, I was whisked away by large cars to salmon rivers in Scotland or given air tickets and expenses to take my easel to private estates on the Continent to execute commissions. Tony Christie, the pop singer, became a regular patron and friend, and on a visit to Glasgow to appear on Scottish Television I met the delicious Isla St Clair, who is now very close to my family.

I suppose that by the early seventies I was the best known artist in Yorkshire, if not the Northern counties. But there was an inevitable

backlash. Naturally, the Barnsley art brigade, who have never accepted me, were delighted when I was charged with 'prostituting art'. Most of the voices belonged to failed artists and their supporters, but they had the backing of some of the critics. I suppose I would have been acceptable, maybe a hero, if I had gone around in a kaftan and open sandals shouting for a grant from the Arts Council.

But I have never taken a hand-out in my life and never will. For me, selling my water colours ranks second in priority only to actually painting them. The world does not owe me a living. And if real art comes exclusively from personal suffering, then I reckon I qualify.

The truest friends I had turned out to be people confident enough in their own talent and achievements. Roy Mason quickly became the most prominent of this group and I was welcomed into his inner circle, meeting him regularly during his off-duty moments for a pint in a local pub or Workingmen's Club around the Barnsley area. He succeeded Ron Darwent as the father figure I constantly sought throughout life. It was a happy arrangement, for he has no son, and he is the only man who I will allow to criticise my behaviour.

A plain speaking and honest man is Roy Mason. When he took over as Secretary of State for Northern Ireland his uncompromising attitude to the IRA earned him the title of 'Stone Mason' and changed his life. Wherever he goes now, for as long as he lives, armed security men shadow him. Even on holiday abroad. Once, he invited me over to Belfast as his personal guest, arranging a commission to paint the Short Brothers aviation factory where they made jet aircraft.

It turned out to be a terrifying experience. A chauffeured car met me at the airport and we drove past road-blocks, rock-throwing youths and burning buses to a hotel out in the country. It was a lovely, centuries-old place but I found no comfort there.

That night, Roy Mason threw an impressive dinner in my honour. He arrived in a black Jaguar car, with half an army in close attendance. Two men with sten guns stood guard at the entrance and dozens more surrounded the place. You could not even visit the gent's without staring down a gun barrel.

'What's the matter with you, Jackson,' said Roy, as the meal got under way. 'Why are you so nervous?'

I pointed out that I was unused to dining in a ring of steel.

'Get away, lad. I have to do this every day,' said my important friend.

'Yes, but when you move they move with you. And that leaves me here on my own, one of Stone Mason's big buddies! Thank you very much.'

It was not a happy night. I was so worried about the IRA that I pushed a wardrobe behind my door, fixed pillows as a dummy in the bed and slept in the bath. For two nights.

To cap it all, Short's declared an intense dislike to the painting I had come specially to do. I had a jet flying over an impression of the factory, with a roadblock of concrete filled oildrums in the foreground. They complained that they did not wish to publicise that kind of thing, and what would their American customers think. So I did them another, romanticising their place to a somewhat ridiculous degree by planting the mountains of Mourne in the background. They are quite a long way from Short brothers factory. Roy was most curt with their management, telling them they had rejected a piece of real art, a demonstration of the feelings of the painter when first confronted with the situation in Ulster.

I gave the original to him.

My important friend built up a large collection of my paintings and lost no opportunity to promote me. Because of him, I am a regular visitor to Westminster and several members of both Houses own my work. Once, in his capacity as chairman of the Yorkshire group of MPs, he said he would arrange a one-man exhibition for me at the Mother of Parliaments. It had never been done before.

The idea broadened into an exhibition of work by Yorkshire artists, and the organisation was handed over to some of the county's art elders. They obviously did not think too highly of my stuff because I was excluded. They decided to restrict entry to Yorkshire born artists!

Some of the regional critics wrote scathing pieces about my exhibitions, which irritated me. But there was one wonderfully ironic occasion when I had to present one of my paintings to a man who had

often derided me. It was a public affair, so we both had to smile and pass pleasantaries.

But as I handed it over, I leaned close and hissed: 'Here you are, mate. I'm sure you will hang it in the lavatory, but I'm even more sure you won't destroy it because it has my name on it and it's worth a bob or two!'

It was a good moment.

Today, my early paintings are advertised in the newspapers as investments. They are asking six hundred pounds for works I was grateful to sell for twenty. During the seventies, my prices escalated steadily. From two hundred to three fifty, from four hundred to six hundred. That was in my gallery. In the exclusive places in the major cities they were asking two and even three thousand pounds! And it seemed that the higher the price asked, the better they sold.

In Barnsley, they were even being bought by ordinary working folk, which both delighted and worried me. I overheard couples discussing how they could afford to buy one and deciding that they would use the cash they had saved for, say, a new carpet. And one day a couple spent a long time in my gallery admiring a snow scene, of which I was rather proud and really wanted to keep for an exhibition. So it was priced at a thousand pounds to deter people. They went away, but the man telephoned the following day and asked if it was still for sale. I said it was, so he came in and put down twenty pounds as a deposit. He said his wife had fallen in love with that painting and he wanted to buy it as a surprise for their wedding anniversary.

That time he came by motor bike. But on his next visit, it was by bus. He carried two cheques, one from a Building Society and another from a bank, amounting to nine hundred and eighty pounds. I asked him where the bike was.

'Sold it,' he said. 'It was the only way to raise the money.'

I knocked it down to eight hundred on the spot. When an ordinary working man will make a sacrifice like that for one of my paintings, not a critic in the world can touch me.

Chapter Fourteen

By 1978 I was, by my standards, reasonably wealthy. Art shops were even asking seventy pounds for an Ashley Jackson print and I was paid to endorse art products. And it was not just the fancy prices being asked for the originals, it was the sheer volume of sales. I began to think in terms of limiting my annual output to preserve a certain amount of exclusivity and create a situation where demand exceeded supply.

Enthusiastic support came from all sides. My bank, the Yorkshire Bank, for instance, advertised that they would be willing to offer loans to customers wishing to buy my water colours. My work now decorates the walls of many continents – embassies, Royal houses, multinational boardrooms and residences of millionaires. The chairman of one company acquired a dozen at one go!

A friend, Duncan Haughey, helped me find a large house overlooking the beautiful Pennine town of Holmfirth, with plenty of room in the garden for a heated swimming pool. I added a sauna, bought myself a BMW and a new car for Anne.

Even Hedley was impressed, and when he first came to visit our new property paid me the one and only compliment of his life. Looking around him as he entered he said:

'You've done alright, lad!'

So, financial worry became a thing of the past. But . . . it was replaced by something of an even darker hue. When a man's mind is filled with the ordinary pressures of life, like how to pay the next

119

instalment on the car or whether he will be promoted at work, there is little time to ponder the meaning of life.

Now there has always been a sombre side to my nature which I have usually managed to cloak well by exuding confidence. My sleep has constantly been troubled by dreams full of tortured fantasy. I have thought a lot about death and what sort of mark I will leave on this earth when I go. But before you can reach any satisfactory conclusions in these matters you have to know who you are.

So when success and early middle age – that troublesome time when men traditionally pause to consider what they have done with their life up to then and how they should prepare for the remainder – arrived hand in hand for me they precipitated a crisis which racked my entire being.

I tried in vain to find solace on the high moors, bivouacking alone for days on end attempting to feel close to the earth. The moors have always been like another woman to me and I desperately sought her embrace, hoping to find a release from my burden. But none came. My paintings during this period became darker and darker. In my world, there was always a storm about to break.

Nothing would ease the pain. The problem lay in my very roots, but how could I deal with it unless I was sure of those roots. I realised I had no real idea of my identity.

Who the hell was I?

And so the odyssey began. I put away my paints and began to journey back in time to find the answer. The route lay back across the life of the father I had never known, back to my Spanish grandmother with the enigmatic past and proliferation of names. My only guide was the little red book she bequeathed me and the marriage certificate I tracked down in London.

Maria Therese Rodriguez? I had been so close to her, and yet I never knew her real name until she had been dead for years. What the hell was it all about!

For the first time since I travelled to her death bed, I returned to Limerick. Aunt Mamie was as warm and affectionate as ever and together we found my grandmother's overgrown little grave and

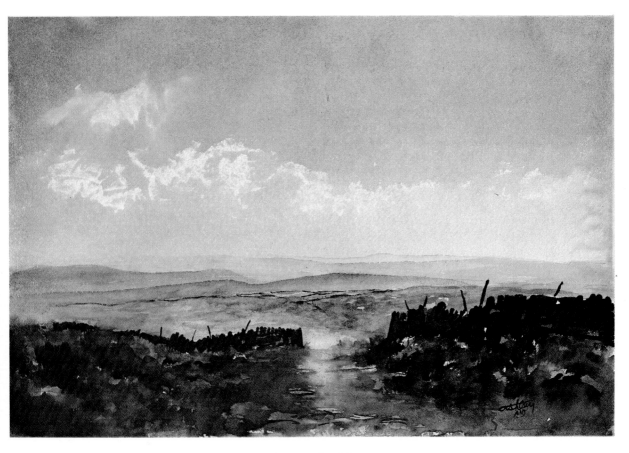

Spring on the Moor

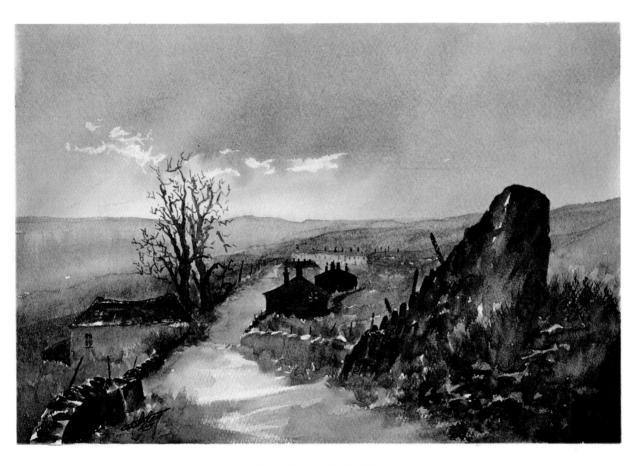

Low Row, Swaledale

wept. But she could shed no further light on her origins, though she did confirm that grandmother had mentioned that her maiden name meant King in Spanish, something she had also told me. That was Rey – nothing like Rodriguez.

So I turned up at the hot and dusty gateway to Seville where my grandmother had been sold at the age of six to the American couple called Hill. And met the redoubtable Perdita Hordern, who was to finally unlock the door for me by sheer enthusiasm and persistence. She began as my paid interpreter but ended a real friend.

It was she who worked out that grandmother's name must have been Rodriguez Rey because all the Spanish retain the maiden name of their mother. Since the wedding certificate listed her father as Manuel Rodriguez, gentleman farmer, it followed that her mother must have been called Rey.

I became excited when I read those words, 'gentleman farmer', reasoning that if Manuel came from a landed family he would be that much easier to trace. But I was told by the British consul in Seville that in the middle of the nineteenth century in Andalucia there were no gentleman farmers. Only poor farmers.

A fruitless and energy-sapping tour of all the Registry Offices in and around Seville then began, led by Perdita. No trace. The birth of my father's mother had simply not been recorded.

At that time I shared my despair with Barry Cockcroft, the television programme maker who had been a friend for ten years, and his crew. Although I had been dubious about sharing such private emotions with a film camera, he had persuaded me that my search for an identity should be recorded, and since I had been given so much help over my entire career from people like him I had agreed. Anyway, I knew I could trust him. He had made many films where complete faith in him with an essential requirement of the principals, and had never abused that trust.

He had invested a large sum of Yorkshire Television's money in the idea and when Perdita drew a blank was naturally worried that the venture would collapse around his head.

It was pure chance, plus hard graft, that Perdita Hordern heard about the Rodriguez Rey family and deduced that my grandmother was a

pure Spanish gipsy, a fact carefully hidden from my family for the best part of a hundred years. Unknown to me – I was painting various aspects of old Seville at the time – she gained an introduction to the head of the family, Amos Rodriguez Rey. She showed him the little red book and explained the circumstances.

It took him a week to decide whether or not to meet me. During that time, he questioned elderly members of his family very closely. Gipsy families in the nineteenth century stayed aloof from the system, a law unto themselves. Their births, deaths and marriages were rarely, if ever, officially recorded. Instead, family histories were handed down by word of mouth from generation to generation.

Amos had the fierce blood of the gipsies coursing through his veins. A noted authority and judge of the entire art of Flamenco, he was a proud and haughty man. His first reaction had been to scorn this curious Englishman who claimed to be the grandson of a woman who allegedly bore the same name as his own. But his researches among his elders had given him pause.

A meeting was arranged.

Just before it took place, Perdita had to tell me something. Bless her, she was in such a state of nerves. She thought I might be shattered by the revelation she must announce.

'. . . your grandmother was a gipsy, a pure Spanish gipsy!'

But the emotion it created within me was sheer, joyous relief. The black mist obscuring my vision of myself began to lift.

The days that followed were as intoxicating as any I have known. I came face to face with Amos who, after a few moments, gazing in disbelief, folded me in an embrace. We looked so alike – the shape of the head, the mouth, the nose! We could have been first cousins. I was whisked away to meet his wife and children. And saw that his eldest daughter was the image of the pictures of my grandmother as a young woman, and also very like my own daughter, Heather. Amos's son closely resembled my own father. It was astounding.

When the excitement subsided, Amos explained gravely that

around the time of my grandmother's birth one of the female members of their family had disappeared. They reasoned that it could have been my great-grandmother. Amos's grandmother had been called Maria, and the name of Dolores, chosen for herself by my grandmother, was considered to be very significant. Traditionally, the first female child of each branch of the family was named Dolores.

Slender evidence, perhaps. But, along with the remarkable physical resemblances, it was enough for Amos and his family to call me cousin and invest me with the medal of the Catholic brotherhood to which they belonged, an honour indeed.

Amos then took me off on a memorable journey. Since I was now part Spanish gipsy I had to display myself to his friends – prove myself, in fact. Along the way I was pushed into a bullring along with his matador friends as they tested the new crop of fighting cows, the future mothers of the bulls bred for the *corrida*, for bravery and stamina. The *Tienta*, they called it. Not long before, a leading matador had been killed at a *Tienta*.

So I found myself sharing a cape with a *novillo*, a young bullfighter just starting his career, as a ferocious black beast charged headlong at us. On the third pass, a needle sharp horn missed my groin by a fraction of an inch. I fled. But I had passed my *Tienta*, and Amos jumped into the ring to embrace me once again.

The climax of this electrifying period was still to come. Every year there is a great pilgrimage, called the *Rossio*, into the arid hinterland of Andalucia. Thousands of people trek slowly along the red dirt roads and over high pasture lands escorting an effigy of the Virgin Mary, carried on a high wheeled wagon dragged by oxen. Pilgrims travel either by foot, on horseback or by horse-drawn carriage. There is no other way to go honourably.

The column converges on a place which looks for all the world like a frontier town from the American West of a century ago. There are low roofed *haciendas*, hitching rails for the horses and not an inch of metalled road. No hotels, no restaurants or cafés, not even a bar. Those who can afford it own a house there and each year for a few days fill the place with family and friends. The entire place explodes into colourful, noisy, wondrous life. A place is found for everyone to sleep,

eat and drink – those who belong, that is. It is no place for the tourist. Outsiders are few and far between.

For this is a gipsy festival, and only those with some genuine Romany blood really belong.

One of the leaders of a Sevillian brotherhood – the same to which I now belonged – was Amos's brother, Benito, a famous Flamenco singer. Amos was eager to introduce me and seek confirmation of his belief that I was of their blood.

As we searched for him amid the swirling crowds, my senses were swamped by the clamour and excitement. An all-pervading, fine cloud of dust, hammered into the atmosphere by the hooves of a thousand superb horses, almost obscured the burning sun. The heat was oppressive, but at every street corner groups of people, the women and young girls ablaze with the traditional frilled dresses of the Flamenco dancer, whirled and stamped their feet to the music.

I felt my hair stand on end when I watched the young girls, some mere tots, dancing with such dramatic skill for I realised that my Spanish grandmother almost certainly danced on the same piece of earth all those years ago. Maybe it was here that the Hill family saw her for the first time, and arranged to buy her. What had driven her own mother to allow it? It could only have been hunger, allied to a desire to ensure her child had a better chance in life. Like me, my grandmother had a step-father. Her own father had died when she was very young.

The time came for me to meet Benito Rodriguez Rey. It was a formal, long drawn out business. Messages had been sent and returned. He was waiting in the house of a friend. I entered, drank the obligatory glass of Fino, and turned to see a thin, hawkish man gazing at me in mute amazement. As Perdita tried to effect a proper introduction he flung his arms around me and wept unashamedly. It took him a full five minutes to recover from the shock of seeing me, a total stranger bearing so many of the physical characteristics of his male line. As we drank symbolically from the same silver cup, he was still incapable of speech. Before the meeting, he was already caught up in the emotion of the pilgrimage and my arrival had almost been too much for him.

Benito had no doubts about my pedigree.

The next hour was spent in a detailed examination of the little red

book, punctuated by excited chatter as various pieces of evidence were weighed and discussed. They pointed out that the photographs of my grandmother in Flamenco pose, particularly the style and positioning of the hands and feet, proved beyond doubt that she had been trained in Seville.

There followed a party of enormous dimensions, singing and dancing and drinking until the dawn broke.

And so, in the summer of my fortieth year and a thousand miles from the Pennines, I found myself. The shackles were struck from my soul. I was free.

I returned to my home in peace, and went back to my high moors, back to the wind and driving rain, to resume my life.

I am Ashley Norman Jackson, directly descended from a noble line of the most romantic people on earth.

I will die happy in that knowledge.